Supplementary

POST-PRODUCTION
BLACK & WHITE

n. work done on a film or
recording after filming or
recording has taken place.

 ava | Acade
the environment

An AVA Book
Published by AVA Publishing SA
Rue des Fontenailles 16
Case Postale
1000 Lausanne 6
Switzerland
Tel: +41 786 005 109
Email: enquiries@avabooks.ch

Distributed by Thames & Hudson (ex-North America)
181a High Holborn
London WC1V 7QX
United Kingdom
Tel: +44 20 7845 5000
Fax: +44 20 7845 5055
Email: sales@thameshudson.co.uk
www.thamesandhudson.com

Distributed in the USA & Canada by:
Watson-Guptill Publications
770 Broadway
New York, New York 10003
USA
Fax: +1 646 654 5487
Email: info@watsonguptill.com
www.watsonguptill.com

English Language Support Office
AVA Publishing (UK) Ltd.
Tel: +44 1903 204 455
Email: enquiries@avabooks.co.uk

ISBN 2-940373-05-1 and 978-2-940373-05-5

10 9 8 7 6 5 4 3 2 1

Design by Gavin Ambrose (gavinambrose.co.uk)

Production by AVA Book Production Pte. Ltd., Singapore
Tel: +65 6334 8173
Fax: +65 6259 9830
Email: production@avabooks.com.sg

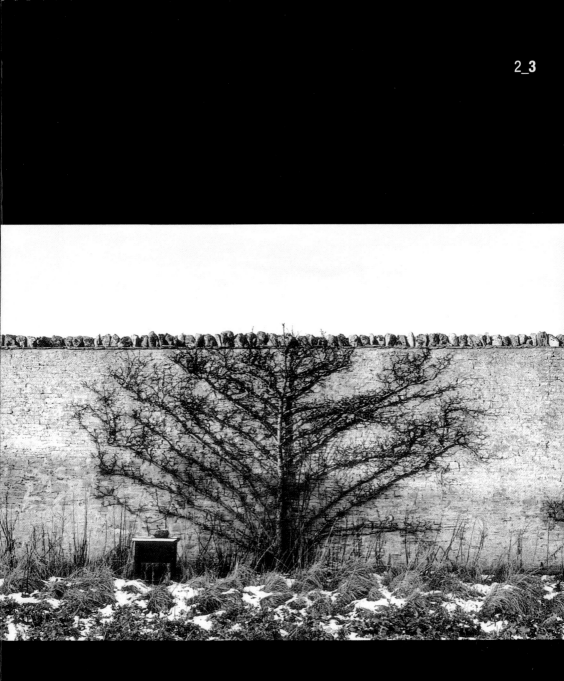

Tree, wall, Sandside, Caithness (above)

The photographer discovered a secret Victorian garden while out on a long walk, which made for a stunning black-and-white photograph featuring various textures.

Photographer: Steve Macleod.

Technical summary: Nikon FM, 50mm lens, Ilford HP5 rated and processed normal, printed on Ilford 1K RC Lustre.

Contents ▷

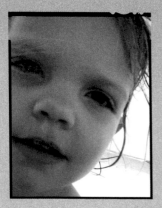 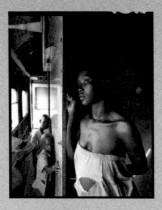

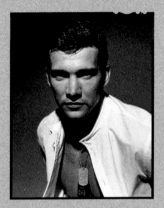

This book features dedicated chapters that explain how to successfully produce stunning prints and images in black and white, using both film and digital media. The following chapters will cover topics including the methods used in both traditional and digital darkrooms. The last section will also discuss the importance of portfolio development and delivering presentations – both essential skills for any photographer embarking on securing commissions.

Main chapter pages
These offer a précis of the basic concepts that will be discussed.

Headings
Headings run throughout each chapter to provide a clear visual indication of your current location.

Introductions
Special chapter introductions outline basic concepts that will be discussed.

Techniques for printing from film ▷ ◄

90_91

In the last two chapters we explored many of the stages that go towards producing photographic prints. Now we need to look more closely at the mechanics. A sound understanding of the processes – both basic and advanced – used in the darkroom also relies on knowledge of the underlying technology. We will look at paper construction, the ranges of paper currently on the market, and how we can successfully use various paper types in the darkroom.

There are additional techniques that can be employed on top of making straight prints. These techniques help to enhance the longevity of prints and extend the limits and capabilities of certain paper stocks. This chapter will also address key issues involved in producing high-quality prints across a much wider range of situations, from a wider array of original negatives.

'The marvels of daily life are exciting; no movie director can arrange the unexpected that you find in the street.'
Robert Doisneau

Tulip (facing page)
This is an example of a post-flashed print, which maintains subtle highlight details.
Photographer: Bruce Rae.
Technical summary: Agfa Multicontrast paper, developed in Agfa Neutol WA developer.

Introductory images
Introductory images give a visual indication of the context for each chapter.

Quotations
The pertinent thoughts and comments of famous photographers, artists, philosophers and photographic commentators.

Image captions
Captions call attention to particular concepts covered in the text and almost always list equipment used, exposure details and any other relevant technical information.

Running glossary/Author's tip
These are included to explain technical terms or offer advice.

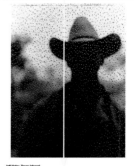

Jeff Haley, Texas (above)
Unlike conventional film Polaroid Type 55 provides the photographer with an instant negative and positive. Once 'processed' the negative can be used directly in the enlarger to produce fine prints.
Photographer: Jon Nicholson.
Technical summary: 5" x 4" Polaroid Type 55, printed on Agfa Multicontrast FB, with a slight selenium split tone.

Prague trees (right and facing page)
This image was scanned for maximum detail; it is open and has a wide tonal range – the preferred starting point of most digital operators. The following images show adjustments applied to the original image using the Curves tool.
Photographer: Steve Macleod.
Technical summary: Rolleiflex 2.8 GX, Kodak TRI-X 400 rated at 320, processed normal. The negative was hi-res drum-scanned and was produced as a test image for the digital FB paper used.

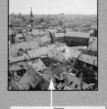
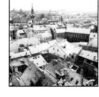

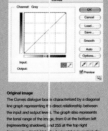

Original Image
The Curves dialogue box is characterised by a diagonal line graph representing the direct relationship between the input and output levels. The graph also represents the tonal range of the image, from 0 at the bottom left (representing shadows), and 255 at the top right (representing highlights). The horizontal axis controls the input values and the vertical axis the output values.

Image 2
Using the Curves dialogue box, more contrast was added to the image by clicking about three quarters of the way up the linear line, thus creating an 'S' curve similar to that of analogue film. This introduced contrast to the image, resulting in a much cleaner looking image than the original file.

Image 3
On the horizontal output bar of the Curves graph there are two small arrows. By clicking on these the input and output ranges will become reversed, and by also holding down Alt and clicking anywhere on the grid area, the grid unit measure will toggle between 25 and 10 per cent units, allowing for more accurate control.

Images
All the images have been carefully chosen to illustrate the principles under discussion.

Diagrams
Diagrams explain technical concepts clearly and concisely.

Introduction ⊳

Having worked in the professional photographic lab industry for many years and experienced first-hand the great advancements in digital technology, it is encouraging that I find myself writing a volume on both analogue and digital post-production. It is interesting to note that darkroom practices are now termed conventional in the same way that older historical processes are now termed 'alternative'. There has always been a technical evolution in photography. Digital does not take away from analogue and as long as there are people interested and passionate about any of these practices then there will always be people willing to take the time and learn the skills necessary to craft a fine print.

My own inspiration comes from the people I have encountered along the way. I have found myself in a fortunate position of being able to practice at the very highest level professionally and also to lecture at photography colleges with what I hope are future image-makers.

I always encounter an enthusiasm for processing and I hope that this book is received as a working reference guide rather than simply a display of great images and printing methods. It is not my wish for this volume to be used rote fashion. I am more interested in other people's experiences and skill levels, and I prefer for people not to copy what I do, but to learn and gain some helpful advice along the way based on my own mistakes – and believe me I have made them all!

Any opinions and observations that I make are done with genuine intention and are based on my own findings, but by no means do I pretend to know it all. These notes are made from practical experience and I believe that sharing these experiences is integral to photographic practice.

Getting started

This chapter looks at the various cameras available and the similarities and differences between a traditional and digital darkroom.

Film and digital file formats

This chapter explores the different film and digital files available, and looks at how to better process and manage them in order to create successful prints.

Basic image manipulation

Here, the basic adjustments that can be done during the developing process will be explored in order to produce better photographs.

Techniques for printing from film

In this chapter basic and advanced techniques in the traditional darkroom are revealed, including various paper types and how to use them effectively.

Digital post-production techniques

This chapter will cover some techniques that can be applied to digital images in order to emulate or even exceed the quality of traditional prints.

Presentation

This final chapter will look at how to put together professional-looking portfolios and deliver successful presentations and pitches to secure commissions.

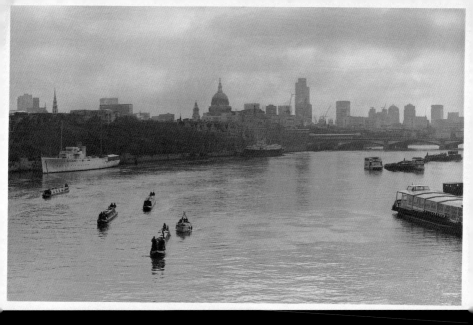

The Thames (above)

This image was taken by a food photographer, who also enjoys landscape photography.
Pre-flashing the print during printing was done in order to add depth during toning.

Photographer: Mike McGoran.

Technical summary: Kentmere Art Classic paper, thiocarbamide toner, overlaid with Rayco blue toner.

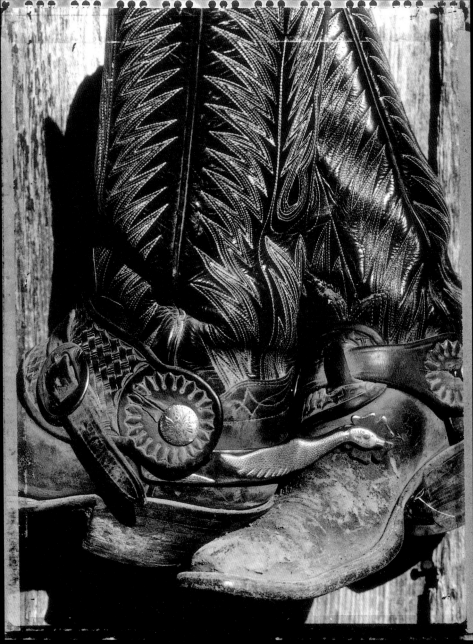

There are several things to consider when starting out in black-and-white photography production. First we need to consider the equipment – the cameras – with which we will be taking our photographs. We then need to consider the environment in which we will be processing and producing our prints. Traditionally, this would have been the darkroom – and for many photographers it still is – but we also have to take into account the impact of digital photography. We now have the additional option of what we might call a digital darkroom: a computer workstation dedicated to high-quality image manipulation and production.

Whether working traditionally or digitally it is important to bear in mind what needs to be achieved and how important it is that the photographer himself undertakes the process. The processes that take place between shooting a photograph and producing a print are perceived by many as something of a mysterious black art. However, crafting beautiful photographic prints is a skill that anyone can achieve; the ability to take and translate creative images is all the more improved if the photographer fully understands the equipment available and how effectively it works. Therefore, as with any applied craft, we must spend some time investigating the tools of the trade before utilising them in creative application.

'The world just does not fit conveniently into the format of a 35mm camera.'
W. Eugene Smith

Cowboy boots (facing page)
This is an image from Jon Nicholson's book, *Cowboys: A Vanishing World*. Jon spent months working and living with the last real cowboys.

Photographer: Jon Nicholson.

Technical summary: MPP Mk VIII field camera, Kodak TRI-X 5" x 4" rated at 320, processed normal, printed on Agfa Multicontrast FB.

Cameras

Cameras today come in all shapes and sizes. There are simple ones, such as those found on mobile phones, and complex ones, such as large-format film cameras. In between this scale, almost every photographic need and budget is catered for. We are also at a stage in photography where film and chemical-based photography is rapidly giving way to digital. In only a few years digital photography has developed from a low-quality computer-based curiosity into something that, in terms of quality, can rival film technology and, in many areas, exceed it.

Whichever course you choose to take with your cameras, conventional or digital (and there's no reason that you should stick to one) you need to ensure that your cameras are 'fit for purpose'. A well-specified compact camera may be capable of producing sharp images to A4 size but if you or a client need large A2- or A1-sized prints, the camera will be unable to deliver. Similarly, a large format camera will be inappropriate for getting fast-action shots at a sporting event.

When choosing a camera or camera system to invest in, consider your needs carefully. Weigh up how you might expect those needs to evolve in the future. You need to ensure that you have shortlisted equipment that will meet all the demands that might reasonably be made on it. Cameras, whether digital- or film-based, tend to fall into distinct categories: compacts, intermediate, professional and specialist. It makes sense at this point to take a look at eachof these with particular reference to their intended user, and the uses to which they are best suited.

Compact cameras

Often described as 'entry-level' cameras, compacts are available in both film and digital versions. Although the most basic tend to offer mediocre image quality (sufficient for small prints and use on sunny days) most compacts today are equipped with good quality lenses and exposure systems that can produce great images across a wide range of conditions. Compacts are the preferred camera of the casual snap-shooter, but many professionals carry one too. They are ideal for those 'grabbed shots' when it is not possible or viable to use your main camera. Compact digital cameras generally offer file sizes in the range of three to six megapixels (three to six million pixels of resolution). A six megapixel sensor will be capable of producing high-resolution prints up to A4 size. Compact cameras provide ample quality for images that are to be used on websites.

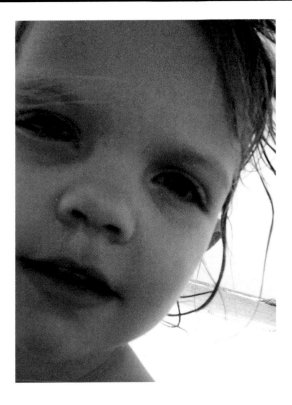

Milli (left)

This image was from a low-resolution jpeg file from an entry-level camera; minimal adjustments were made in iPhoto.

Photographer: Steve Macleod.

Technical summary: Kodak EasyShare, 388KB file, f5.2, converted to black and white in iPhoto.

Window (right)

This image was from a larger jpeg file from a compact camera. Additional adjustments were made in iPhoto.

Photographer: Steve Macleod.

Technical summary: Sony DSC-P200, 2MB, f7.9, 1/25th sec, shot in RGB and then converted to black and white, contrast lowered and darkened.

Intermediate cameras

Intermediate cameras include rangefinder cameras (such as the Leica 'M' series) and entry-level single lens reflex (SLR) cameras. SLRs use a single lens for shooting the image while providing the view in the viewfinder. A mirror, which directs the view from the lens to the eyepiece, lifts up to allow light through the film or digital sensor where the shutter release is pressed. These cameras are characterised by the pentaprism – a large 'bump' over the lens, which houses the viewing system.

Some SLRs feature large zoom lenses in place of the more modest examples on compacts. These are sometimes known as hybrid cameras. Standard SLRs feature interchangeable lenses whereby the standard lens can be detached and swapped for an alternative lens (such as a wide-angle lens or a telephoto zoom lens). Intermediate digital SLRs will produce file sizes of up to ten megapixels, which is sufficient for an A3 print. These cameras are great for general photography and their exposure systems are sufficient for all but the most extreme of conditions. They may, however, be compromised in ultimate exposure control and shooting speeds.

'Photography is a love affair with life.'
Burk Uzzle

Old woman, Georgia (facing page)
This photograph was shot in the former Soviet State of Georgia before the fall of communism and the opening up of the East. The subject was very lively and the light was low – the only opportunity for a decent shot came when someone opened the door to enter the room. The image was shot and the composition adjusted later.

Photographer: Steve Macleod.

Technical summary: Nikon FE, Ilford HP5 rated at 800ASA, process +1, printed on Agfa Record Rapid and part selenium toned.

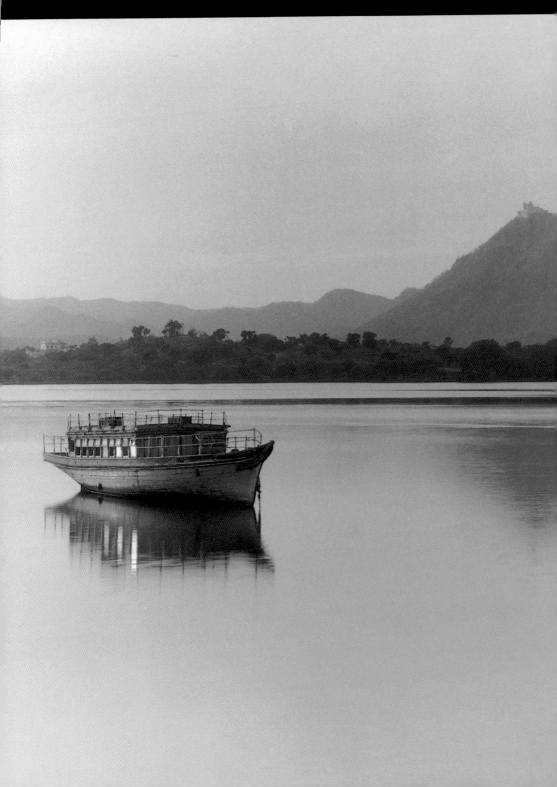

Professional cameras

The greater demands of professional users mean that their cameras tend to be more robust, offering greater manual control and higher resolution sensors. Professional digital SLRs are now commonplace amongst photographers and have supplanted their film-based siblings particularly in press, sports and news applications where the results can be speedily and electronically delivered to newspapers and magazines. Film-based cameras can still be found in this category, with both 35mm and larger format SLRs being used in a number of studio situations where the largest possible resolution is considered essential. Digital SLRs offer resolutions of up to 20 megapixels and are suitable for a wide range of photographic genres.

Morning sun (facing page)

This image was taken early in the morning and the print was toned to add warmth. This is a good example of the fine grain and detail possible with a medium-format camera.

Photographer: Samman.

Technical summary: Hasselblad CM, Ilford FP4 rated at normal, toned with a light thiocarbamide.

Specialist cameras

The professional cameras described previously make up the staple equipment of the professional user, but photographers who specialise in certain types of photography (i.e. advertising, architecture or landscape photography) will require specialised cameras. These cameras are used only occasionally by less experienced photographers.

High-end digital backs contain a digital CCD sensor that attaches directly on to the back of medium- and large-format bodies. Designed for ultimate digital capture, these backs can either be connected to a computer, hard drive or used as a self-contained unit like a normal camera but with a built-in LCD screen. File sizes can reach up to 117 megabytes / 39 megapixels and 35 frames per minute, and images can be stored on microdrive or compact flash memory cards. They are also aligned with file processing software, such as the popular Capture One RAW workflow package. Using sheet film in dark slides, they provide the highest quality negatives and commonly range from 5" x 4" up to 11" x 14" in size. They are particularly useful because the front and rear planes of the camera can be adjusted to ensure that converging verticals are avoided. This is a problem usually encountered in conventional cameras where a slight tilt in the camera produces distortion to any vertical lines.

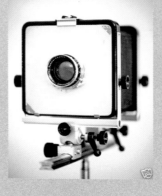

The Phase One P45 back
A professional large-format digital back is slowly becoming more economical and many outfits can be hired at minimum rates.

The Arca Swiss 5" x 4"
Monorail camera
The sheet film file format is now having a resurgence in popularity.

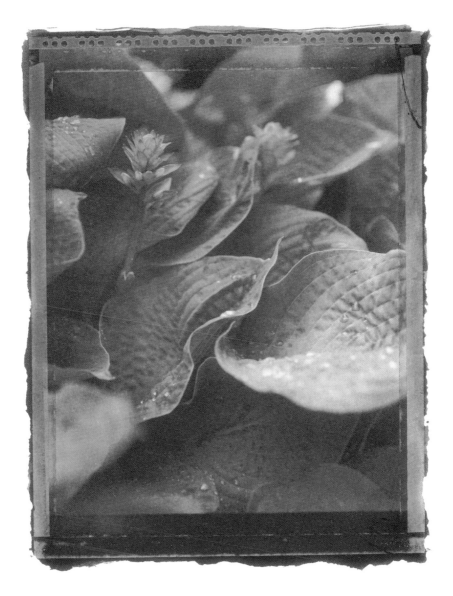

Hostas (above)

This image was shot on a rainy day when the light was flat and low. The photograph clearly shows the different results that can be achieved using a specialist camera.

Photographer: Steve Macleod.

Technical summary: MPP Mk VII, 5'' x 4'' film, f16 1/15th sec, printed with a rough-edge keyline.

The darkroom

Until recently, just about every professional photographer's studio would feature a darkroom. For some the darkroom provides the means to deliver images fast; for others it provides the ultimate in post-production creativity. Although digital technology has seen greater growth in the digital darkroom – centred on the computer workstation – the conventional darkroom is certainly not destined to become a historical relic. The following explores the components that make up the darkroom, be it a custom-built room or the proverbial cupboard under the stairs.

The enlarger

This is the key tool for producing prints. It is the enlarger that projects light through the negative film and lens on to light-sensitive paper in order to produce photographic prints. The move to digital photography (where the enlarger is replaced by a computer workstation and printer) has meant that there are fewer enlarger models on the market today, but they are very competent, professional machines. There are three main types of enlargers:

Point source enlargers: Provide the hardest of all light, which tends to enhance the sharpness of grain (not to be confused with image sharpness) in the original negatives. These produce images of exemplary clarity and very clear 'salt and pepper' grain. However, they are also prone to show up dust, scratches and imperfections on the print. The light is projected through a series of lenses and the resulting images can be considered quite cold.

Condenser and diffuser enlargers: Use a 'mixer box' (the condenser) to spread the light from the enlarger bulb evenly over the negative. This results in a very evenly lit image on the baseboard, but without the harsh sharpness of a point-source enlarger.

Cold cathode enlargers: Provide the softest working light. This can be useful as it may mask imperfections on the negative. However, the way the light is provided (through a series of tubes) can attenuate the light and reduce its intensity. They can also emit light with a strong colour cast. This cast can interfere with special filters used to control the contrast on some printing papers, making cold cathode enlargers unsuitable for use with variable contrast printing papers.

It is worth noting that most enlargers allow you to control the contrast in the prints you produce. This can be achieved by using slot-in filters inserted above or below the lens, or a special 'variable contrast' light source that can be altered by a special dial-in control panel. This is a dedicated light source where the filtration is dialled in for the single light source, or a twin lamp enlarger where the balance of each colour of lamp is adjusted to alter the contrast filtration.

Most educational establishments use colour enlargers for both colour and black-and-white printing and feature cyan, magenta and yellow dial-in filtration. However, most black-and-white photographers will be quick to point out that the strength of the light source and the equivalent filter readings in these enlargers do not equal those of a designated black-and-white filter system.

The negative carrier

Another important feature of the enlarger is the carrier: the small unit that holds the negative. Carriers are either made of glass or are glassless. Glass carriers tend to be preferred by users of medium- and large-format negatives. These negatives are larger and thinner than 35mm film. They are more likely to become distorted if not supported by glass, which leads to areas of poor focus. However, glass carriers tend to attract more dust on to the image surface. There are fewer dust problems with glassless carriers but you may find that as your negative warms up, it will 'pop' out of focus and have to be realigned. Some 35mm carriers have glass on the top and a glassless bottom, as these negatives only tend to pop upwards. Negatives can be taped to the carrier using low-tack masking tape; be careful when handling negatives and avoid the emulsion side with any tape or fingers.

Lenses and focusing

It is often said that a camera is only as good as its lens. Although this is not strictly true (a good camera is the sum of a number of good parts) it is equally true that an enlarger will only offer the best results when equipped with a good lens. Like camera lenses there are models produced by manufacturers as well as third parties. It is worth investing in a good quality lens, taking on board the recommendations of the enlarger manufacturer and those of other users. It is also useful to understand how lenses focus. Some lenses can be focused like camera lenses, while others can be re-positioned by using a large rack on the enlarger body. There are even auto-focus models that use an auto-focus or cantilever mechanism to ensure images are always focused on the baseboard. For critical sharpness some photographers invest in a focus finder. This small device rests on the baseboard and uses a reflex mirror, which allows for close examination of the projected image.

Easel and baseboards

Two frequently neglected parts of the enlarger are the baseboard and easel. Too many photographers rely on luck and rest their paper on the baseboard, hoping for the best. Unfortunately, paper can bow upwards in the moist air of a darkroom and ruin the critical focus. For a very nominal cost an easel comprising of a pair of L-shaped blades can be used to hold down the edges of the paper.

Timing

Timing is also critical when exposing photographic paper in the enlarger. Some enlargers have built-in timers. Make sure to equip your enlarger with a timer – it will make for better and more consistent prints.

Processing trays and film tanks

In professional laboratories resin paper is commonly processed by machine, whereas fibre paper is always tray processed. For each print size that you intend to make, four trays are required for the process. These trays will each contain the developer, stop bath, fixer and first wash; it is good practice to label each tray.

In general, the tray size will be one size bigger than the paper size you are using. If you can find different coloured trays – ones that are distinguishable under safelight conditions, so much the better. Think black for developer; white for fixer; and grey for stop bath and water. Trays will lose their heat quite quickly so either use a tray filled with water one size up, with a submersible aquarium heater in the outer tray to keep the temperature constant, or use a purpose-built tray warmer that is repellent to water.

Processing trays
It is a good idea to use different coloured trays for the various parts of the developing process.

If you intend to process your own film you will also need processing tanks. These are light tight so you will only need to work in darkroom conditions (complete darkness) when loading the film into the tank. Loading 35mm film on to the spirals of a tank is pretty simple and easy, even for a long length (i.e. 36 exposures). However, 120 medium format can be more problematic as it has a thinner film base, making it is easy to bend and damage. Practise loading with some damaged film until the process becomes second nature.

'Photography is not about the thing photographed. It is about how that thing looks photographed.'
Garry Winogrand

Chemicals

The chemicals needed for processing must be properly stored. Light can speed up the deterioration of developers and fixers, so dark and airtight containers are required. Keep a note of when you mixed up or first used the chemicals.

Some chemicals have a fixed shelf life and should be discarded after a specified time; other chemicals need to be discarded after a fixed number of films (or paper sheets) have been processed. You may also have to modify the processing times as the chemicals get progressively depleted through use, so make sure to keep the documentation that comes with each.

Processing chemicals
It is important to follow manufacturers' guidelines when using processing chemicals.

Lighting

Unlike colour darkrooms, it is possible to work under 'safelight' conditions in the black-and-white darkroom. A safelight is a source of illumination, which will not cause a visible change to light-sensitive material. Variable contrast (VC) papers are sensitive to green and blue light, hence these papers tend to require red or amber light. Amber can offer better visibility, but different manufacturers supply varying types of safelight filter and colour.

Safelight bulbs can also replace white light bulb fittings. The positioning of the safelight is important: never mount a lamp too close to the enlarger (where it could be at risk of fogging the paper) or in a position where it may cast a shadow over the working area. As a simple test, place a piece of paper on the easel in safelight conditions; leave it for five minutes and then progressively cover up the sheet with card in five-minute intervals. Safelight fogging will appear as grey banding on the processed paper. Check the positioning of your lights and also check for stray white light coming from the enlarger, door and ventilation areas. Keeping light sources at least three feet from the work area should provide adequate conditions.

A darkroom safelight
Safelights can be used in black-and-white darkrooms only.

Darkroom layout

Being comfortable in any workspace is important and it is doubly important that the photographer is comfortable in their own darkroom. Work carried out in the darkroom needs to be done carefully and accurately, as working conditions could be potentially adverse. The light levels will be extremely low and the risks posed by unpleasant chemicals must be minimised. Few have the luxury of a bespoke darkroom so most photographers must make use of a room in the home not specifically designed for the purpose.

When creating your darkroom space, the following are essential:

- A light-tight environment
- A dust-free environment
- Good air circulation and extraction

- A source of running water
- Power supply
- Separate dry and wet bench areas

The following must also be considered: How easy is it to access? Will the working area be used for both processing and printing? Which way do you naturally work: left to right or vice versa? Make a list of all the things that may be needed in the darkroom, and a list of all the things that can be stored elsewhere for occasional use. Darkroom practice is a more manual task than digital processing – there is a lot of standing and moving around involved, whereas in a digital 'darkroom' the work is very much computer-based and stationary.

Diagram of a darkroom

This is a schematic view of a typical professional darkroom. Wet and dry areas are kept separate, facing each other.

1 Shelf for chemistry
2 Sink with trays and wash unit
3 **Safelight**
4 **Enlarger**
5 Print easel
6 Paper cutter
7 Safelight ventilation
8 Storage cupboard
9 Extractor fan

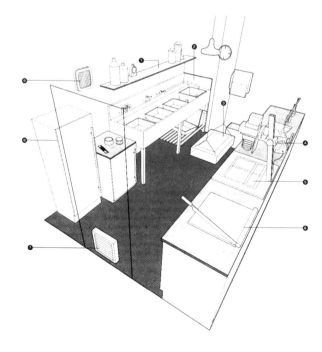

If it is not practical to have a completely light-tight space, a film-loading back can be used to load and unload film cassettes. Removable window screens or blackout material attached by Velcro to the window and door frames is a quick way of preparing a room. Fold-down or temporary worktops can be used over the sink or bath if necessary and, if used as part of a routine, will make the process of printing quicker and more straightforward.

Ensure that dry and wet working areas are kept separate; if you cannot use opposite sides of the room, a partition down the middle will suffice. The dry area will be for the enlarger, negatives, paper and for loading/unloading film. The wet area will be for trays, tanks and anything associated in processing, printing and toning. Running water is preferable but not always necessary. Prints can be stored for short periods in a tray of water, and periodical exchanges of water can be made until you are able to finish the session and transfer the prints to a running water source. If you are fortunate enough to have a dedicated space it is worth investing in a water filter/temperature control unit that will monitor the flow and the quality of the water being used, particularly when it comes to processing.

Other accessories
Other accessories that may be useful when setting up a darkroom are:

- **Measuring jugs:** To keep each chemical separate and to avoid contamination.

- **Spirit or mercury thermometer:** To ensure that the chemicals are at the right working temperature.

- **A wall-mounted darkroom clock:** To indicate how long prints have been washed for, not to mention how long you have been in there!

Upright washers can also be useful as they ensure that prints have had appropriate washing. They are also space saving devices, as the prints are stacked upright as opposed to flat in an oversized tray.

safelight a light with a coloured filter, which can be used in a darkroom without affecting photo-sensitive film or paper
enlarger photographic equipment that projects light through the negative film and lens on to light-sensitive paper in order to produce photographic prints

The digital darkroom

Many photographers were quick to embrace the **digital darkroom** because it freed them from all the inconsistencies and difficulties of working in a traditional darkroom. It means that work can be carried out in daylight and the photographer still has the ability to manipulate all the factors in order to produce the desired results. Additionally, there are no harmful chemicals to contend with. Let's take a look at the key components of a digital workspace and how they fit together.

The computer

The computer is the key component of any digital workspace – all image editing and manipulations will be performed here. Nowadays, the capabilities of even the most basic computers exceed the specifications demanded by most image software applications. However, there is no doubt that a computer loaded with memory – RAM – will work more swiftly than one that has modest allocations.

There used to be heated debates as to which computer was best: a Windows PC or a Macintosh. The march of technology has rendered differences – certainly as far as digital imaging is concerned – so small as to be inconsequential. You are likely to find many professionals using Macintosh computers, but you need not feel disadvantaged if you are using a Windows PC.

Like the traditional darkroom space it is important to ensure that the digital working environment is both comfortable and functional. A great deal of time will be spent sitting staring at a screen in a digital darkroom, so a good chair designed for the job is essential. It is also useful to have a space set aside where prints can be easily laid out and compared under controlled lighting.

digital darkroom the traditional darkroom's digital equivalent, which involves using the computer and software applications as tools to process digital images and create prints

cathode ray tube (CRT) a high-vacuum tube in which cathode rays produce a luminous image on a fluorescent screen, used in televisions and computer terminals

liquid crystal display (LCD) the screen found at the back of digital cameras used to preview images and review photos recorded by the camera

Displays

One of the most underrated components of equipment is the display. There are two types of display: the traditional **cathode ray tube (CRT)** and the increasingly more common **liquid crystal display (LCD)** variety. Both have their advantages: CRT displays can be manually calibrated to produce a neutral output that is easier to fine tune during calibration. However, they are prone to fluctuate in colour temperature. LCD screens cannot be manually corrected and only the screen brightness can be altered. Most people prefer these screens as the contrast is higher and images appear sharper, offering more consistent results once calibrated. With regard to screen sizes, bigger is best. Large LCD screens – up to around 24 inches – are now widely available and allow you a lot of space to work on your images. Image editing software packages provide a great number of features and every additional inch of screen space will be crucial. A large screen certainly makes for more productive working and less strain.

CRT display

Cathode ray tube displays with professional retouchers are still popular as they can be manually calibrated.

LCD display

Liquid crystal display screens are preferred by many users because they offer higher contrast and sharper images. However, they are less adjustable than CRT monitors.

Image-editing applications

To enable the computer to adopt the mantle of image-editing workstation, it must be equipped with the right software. The de facto standard in digital imaging applications is Adobe's Photoshop, the staple of just about every professional photographer involved in digital imaging. Unfortunately, being a professional application it also commands a professional level price. However, if this puts it beyond budget, Adobe also offer Photoshop Elements – a version of Photoshop stripped of the features that are only used by high-end professional users. Other products are also available such as Corel's Paint Shop Pro.

Input devices

Before editing and manipulation of images can begin, digital image files must be loaded on to the computer. To do this most digital cameras can be connected directly to the computer or use a card reader connected to the computer via USB. After connecting a camera to a computer or loading a memory card into the card reader, images can then be downloaded to the computer's hard disc. This process is sem-automatic: both PCs and Macs will recognise there are images to be copied and will prompt the user with a location to save them to. Film or print originals need to be converted to a digital format before they can be manipulated on a computer.

Scanners can also be used to produce digital copies of ordinary prints or other artwork. Scanning devices analyse original material and convert this to digital information and can be 'desktop', 'flatbed', 'film' or high-end 'drum' scanners. Flatbed and film scanners both use Charge Coupled Device (CCD) technology whereas the high-end drum scanners, most commonly used by professional imaging labs, use Photo Multiplier Tube (PMT) technology.

The PMT scanner is very adaptable, particularly when it comes to controlling and smoothing out film grain. The original film is oil mounted between sheets of acetate to minimise dust and ensure even contact to the rotating drum. For most, the results from a flatbed or film scanner are sufficient.

Once images are on the computer and opened up in software they will be ready for modification. Some of these can be made using a mouse – or even the trackpad on a laptop. In order to achieve more control a graphics tablet could be used. This is a pressure-sensitive pad controlled by a pen-like stylus. It makes the work of the operator a more organic one and gives the effect of drawing on screen.

Wacom graphics tablet

A graphics tablet is an indispensable piece of kit for any serious retoucher. It allows for accurate post-production manipulation using the pen and tablet format.

Epson flatbed scanner

A CCD flatbed scanning device is often used for bulk scanning at lower resolutions.

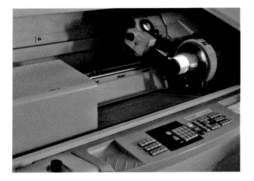

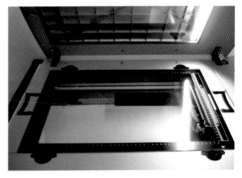

Drum scanner

A professional drum scanning device provides the optimum raw file.

CCD flatbed scanner

Charge Coupled Device scanners provide less accurate resolutions than PMT, but they still provide an economical method of providing raw files.

PMT laser detail

Photomultiplier Tube Drum scanners are popular with professional imaging laboratories, providing a high-resolution file that renders all information.

Printers

Widespread inkjet printers are fairly competent at producing good quality prints from digital files. For best results, it is wise to go for an **inkjet printer** specifically designed for delivering the highest print quality. These printers use special photographic inks and, unlike standard inkjet printers (which use four colour inks) use six, eight or even ten different ink colours. Printing papers that are properly matched to the printer will improve results and offer the optimum print quality – as good as conventional photographs. For black-and-white photography there are special ink sets available that are substituted for the colour inks. These offer shades of grey and can achieve better monochromes than the standard ink sets. These always tend to impart a slight colour cast to black-and-white images.

Calibration devices

One of the most common complaints about digital imaging is the difficulty encountered in trying to match what is on screen to the final print output. Images seen on screen utilise transmitted light whereas prints use reflected light. Therefore, there will always be slight differences, no matter how well the display is calibrated. It is also important to bear in mind when viewing prints that the quality of light they are being viewed in will alter the tone of the print.

It is possible to do a manual display **calibration**, especially with CRT screens, using Adobe Gamma, which is an application that comes with Photoshop that has straightforward on-screen prompts. Other popular hardware calibration systems also provide consistent results such as the Gretag Macbeth Eye-One, which is a **spectrophotometer** that can measure the light wavelength and intensity of any type of display, or ColorVision's monitor Spyder, which is a **colourimeter** device measuring varying light wavelengths.

Layout

The layout of a digital workspace is important, as is the lighting. Good daylight is important but it is best to try to avoid having the computer positioned where light may reflect off the screen or with a bright window behind the screen – both will compromise viewing and could potentially lead to fatigue. Also be aware of external light sources that can affect colour balance, especially ambient light that will change with the seasons. Workflow will be more productive in environments with daylight-balanced light sources and light-balanced viewing booths for colour matching.

inkjet printer a printer in which the characters are formed by minute jets of ink

calibration the adjustment or measurement made on a computer screen to ensure that it is accurate and in accordance with colour standards

spectrophotometer an apparatus used for measuring the intensity of light in a part of the spectrum, especially as transmitted or emitted by particular substances

colourimeter a device used to measure varying light wavelengths

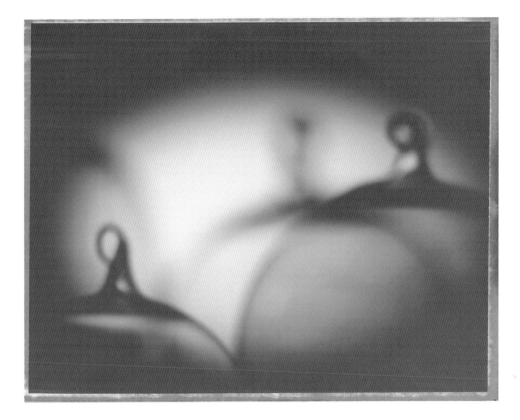

Baubles (above)

This unique and original print was taken from one of the photographer's personal projects while in-between commercial commissions.

Photographer: Chris Turner.

Technical summary: Polaroid Type 55, lith printed in Champion Nova Lith developer, Forte Polywarmtone matt paper.

'If you're photographing in colour you show the colour of their clothes – if you use black and white, you will show the colour of their soul. '

Anonymous

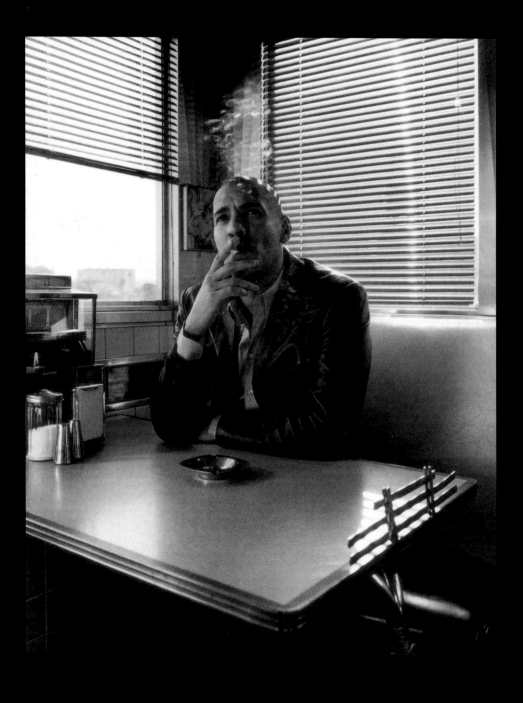

The previous section looked at some of the essential equipment required for both conventional and digital photography. This chapter will now examine some of the issues encountered when using the equipment in real world situations. Film and film processing will be discussed in more detail, as will their digital equivalents. In both cases an overview of the workflow principles involved will be presented, highlighting the key steps that allow for proficient working environments in both conventional film-based and digital domains.

'Buying a Nikon doesn't make you a photographer. It makes you a Nikon owner.'
Author unknown

Stan Collymore (facing opposite)

Hamish Brown is renowned for his strong portrait images. Hamish makes the most out of every situation and produces classic shots in spite of limited time and resources.

Photographer: Hamish Brown / Blunt Management.

Technical summary: Mamiya RZ67, 80mm lens, Kodak TRI-X 400, rated normal and processed +1/2 in Kodak Xtol fine-grain developer, printed on Ilford Warmtone Gloss.

Film types

In spite of the decreasing demand for the film medium due to the inevitable consequence of digital photography, the film-based photographer still has a wide range of emulsions to choose from. The film stock used can have a significant bearing on the images that are produced. Let us examine in more detail the construction and characteristics of film.

How does film work?

Having a basic understanding of how film works will help our general understanding of the photography process. The principles of black-and-white film construction have varied little since its original invention well over a century ago. Film comprises an emulsion of light-sensitive silver halide grains, which undergo a subtle chemical change when exposed to light. This results in a latent image being created. The latent image, although invisible, contains all the information that will be present in the final image. To make it visible the film needs to be developed: a process that causes the silver halide grains exposed to light to turn black and, according to their density, produce all the grey tones in the image. A final fixer bath dissolves away any unexposed parts of the emulsion.

The following is a cross-section of a piece of film:

Anti-scratch layer: A protective coating that prevents damage when loading and unloading and processing. It dissolves during the developing process.

Light-sensitive emulsion: Made up of silver halide grains containing compounds of bromine, chlorine or iodide. These are suspended in a gelatin and applied in several layers. Larger grains make the film more sensitive to light.

Film base: The layer upon which the other layers are deposited. It is designed to be robust, transparent and able to withstand both mechanical and chemical strain.

Anti-halation layer: This very fine layer is similar to the anti-reflective coating on spectacles and camera lenses: it absorbs light passing through the film base, which would otherwise reflect back into the emulsion, causing flare and a 'halo' effect visible around highlights. In some cases this also dissolves during processing.

Anti-scratch layer
Light-sensitive emulsion
Film base

Anti-halation layer

Diagram showing black-and-white-film construction

The above diagram shows the four layers that make up
the emulsion.

Positive and negative films

When a conventional film is processed it delivers a negative image: dark areas represent areas of bright light while dark shadows represent pale areas. When printing from a negative the bright areas will become dark again, and the tonality of the original scene will be reproduced. It is also possible to obtain reversal films, which are also known as slides or transparencies. When processed these produce a film in which the tonality of the original scenes are retained: blacks are blacks, whites are white.

Film speed

The sensitivity of a film is generally described as its speed. As noted earlier, a film with larger silver halide grains is more sensitive to light than a film with smaller grains. There have been several different scales employed to accurately represent a film's sensitivity. Traditionally these have been the American Standards Association (ASA) scale, which is based on a proportional system, and the Deutsche Industrie Norm (DIN), a logarithmic scale. These have now been combined to produce the International Standards Organisation (ISO) scale.

Manufactured film speed is calculated on the same proportional scale as ASA, where most common types fall within the region of ISO 25 and ISO 3200. A film that has double the ISO rating of another is twice as sensitive to light and, in exposure terms, will require one stop less exposure. Similarly, a film that has half the ISO rating of another will require one more stop exposure or need an exposure time twice as long.

The use of photographic film is declining, but there is still a very healthy range of film to meet most photographers' needs. Photographers generally become very familiar with the characteristics of a particular type of film and when they need something more (or less) sensitive they will modify processing times to alter its nominal speed. Photographers call this 'pulling' (downrating) or 'pushing' (uprating) – reducing or increasing the sensitivity of the film respectively.

Chemical processing times need to be modified to achieve a specific film speed. By uprating a film through extending development, contrast will be increased, whereas downrating (and curtailed development) will decrease contrast. Each film will have its own characteristic curve, as seen in the diagram on the facing page. The higher the contrast of a film, the steeper the density curve. When we increase development time the 'toe' of the curve will move to the left – indicating that less exposure is needed to reach the film base fog level.

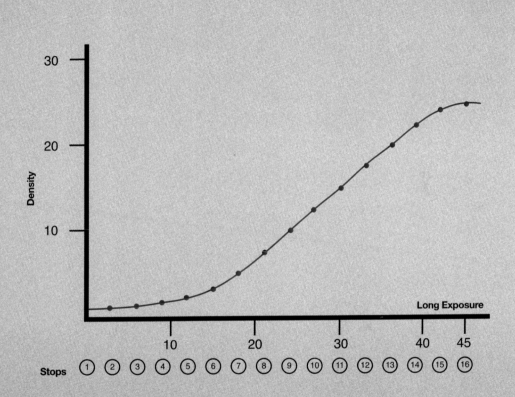

Diagram of exposure curve
This diagram shows the
correlation between exposure,
time and density.

Film grain

We have already seen that film is composed of grains; the faster the speed of the film, the larger the grains of silver. The size of these grains is determined during manufacture, and, to a lesser degree, by the developer used when processing. Sometimes the grains will clump together and give a coarse 'salt and pepper' look.

Photographers tend to view film grain with a degree of ambivalence. On one hand it compromises image quality: shooting at low light levels using fast film means that the grain becomes very obvious, and the effect on contrast can deliver results that look flat. On the other hand, grain structure and appearance are often considered useful creative tools as they impart a sort of grittiness to images.

Negative resolution and acutance can also affect the appearance of the negative. Resolution is the ability of film to render fine graduated detail: it is also known as 'resolving power'. Take, for example, a shot of a model. High-resolution film will show more detail in the hair compared to a low-resolution film. Acutance is a measure of edge sharpness and definition of individual grains. Over exposure or extended development can decrease film acutance and can also lead to enhanced grain appearance.

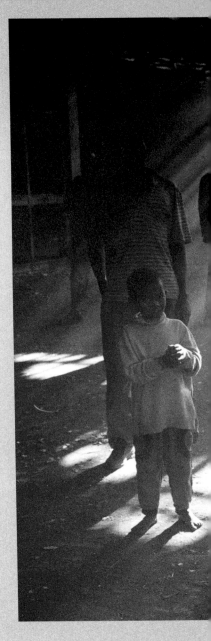

Ethiopia (facing page)

This image demonstrates how one can use low light to enhance image results. Emphasis on the beams of light and darkness resulted in a sombre mood on print.

Photographer: Jon Nicholson.

Technical summary: Ilford HP5+ rated at +1/2, processed at +1/2, printed on Ilford Multigrade Warmtone Semi-Matt paper.

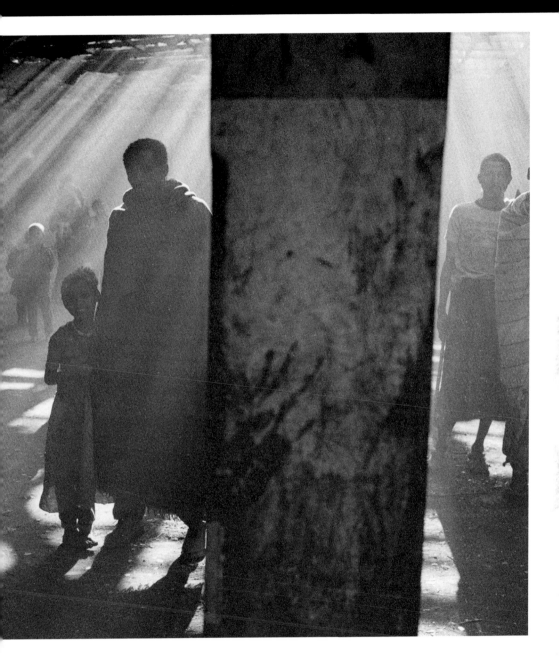

Film type, quality and brands

There is a film available to suit every photographer's needs. For example, images requiring high resolution and detail would call for a fine-grain ISO 50 film. Shots that need to be grabbed in dark conditions, would require a film that allows fast exposures in dark conditions. In recent years film manufacture and range have decreased, but there is still a surprisingly wide range of film types available to suit most requirements. Some popular film types are listed below:

Ilford delta film Ilford HP5 film Ilford 3200 film

Author's tip

Despite the popularity of digital photography a solid core of black-and-white films remain on sale. The following are some examples:

- Ilford Pan F is an ISO 50 panchromatic film that produces very fine grain and medium contrast.
- Ilford Delta 100 is an exceptional fine grain film with medium speed.
- Ilford FP4, is a fine grain medium speed film with ISO 125. It has a refined exposure latitude and grain acutance.
- Kodak PLUS-X is a rival to FP4, but creates more contrast. Good film for studio photography.
- Ilford Delta 400 is a fast fine grain film that can be pushed up to EI1600.
- Ilford HP5+ is a standard high-speed ISO 400 film that has a medium contrast emulsion that push processes well.
- Kodak TRI-X competes with the HP5+ and can be push processed.
- Fuji Neopan 400 has a modified grain structure that gives the appearance of fine grain.
- Kodak T-MAX 400 is a high-speed film with a very fine grain, but the negative can appear thin and underexposed.
- Fuji Neopan 1600 has similar characteristics to the Neopan 400 and works well up to rating of EI3200.
- Ilford Delta 3200 is a genuine high-speed film that has a normal rating of EI6400 down to EI1600.
- Kodak T-MAX 3200 works well in low-light situations rated at EI6400.

Blind girl, Nova Huta, Poland (above)

This image uses the limited light available to full advantage. The film was pushed up to 1600 ISO and still retained enough detail.

Photographer: Steve Macleod.

Technical summary: Nikon FE, f8 at 1/60th sec, Ilford HP5+ rated at 800, developed in Ilford Perceptol 1:3, 18 minutes.

Exposure

Exposure is the act of allowing light to reach photographic film to produce images. Its basic principles are very simple and provide a good grounding from which to start developing photographic expertise. The fundamentals of exposure are best understood if the camera is thought of as a light-tight box. We can let light in through the lens, but it is crucial that we allow in only the precise amount of light to properly expose the film. Too much light or overexposure will result in images with no details in the highlight areas. On the other hand, underexposure will result in a dull and dark image.

The amount of light entering the lens can be controlled in two ways: by varying the shutter opening time, and by adjusting the aperture of the lens. The longer the shutter is open, the more light will be allowed. Similarly the wider the aperture, the more light that will reach the film. The amount of light entering the lens must be quantitatively accurate to ensure that consistent exposures are achieved for specific film types.

Shutter speeds and apertures are correlated to a scale common to all cameras and lenses. Shutter speeds follow the progression (in seconds): 1, 1/2, 1/4, 1/8, 1/16, 1/30, 1/60, 1/125, 1/250, 1/500, 1/1000. Some cameras will offer additional speeds above and below this range. Similarly, apertures are calibrated in 'stops': f2, f2.8, f4, f5.6, f8, f11, f16 and so on. Each successive stop is one half the size of the previous. As a result, if the aperture is altered by one stop, or the shutter speed by one increment, the amount of light the film will receive will either be halved or doubled. If the range is taken from the largest aperture and slowest shutter speed through to the smallest aperture and fastest shutter speed, there will be a very wide range of exposures – a range that should accommodate most shooting conditions when coupled with an appropriate film, from the brightest daylight conditions through to night time.

Author's tip

The correlation between exposure time and aperture is precise and linear for the most part. However, this correlation becomes more complex when dealing with very brief or long exposures. This breakdown in reciprocal relationship between aperture and shutter speed is called 'reciprocity failure'. The ability to compensate for this failure varies according to the film used. The values given below represent a good average correction:

Exposure time	RF exposure adjustment
1/1000s	none
1/100s	none
1/10s	none
1s	1/2 stop more exposure
10s	1 stop more exposure
100s	1 1/2 stop more exposure

It is also important to be aware that different combinations of shutter speeds and apertures actually give the same overall exposure. For example, an exposure of 1/500 sec at f4 is the same as 1/250 sec at f5.6. In this case the exposure time has been doubled but the lens aperture halved. This allows for accurate exposures at different shutter speeds and different apertures to vary the depth of field. Both of these techniques are used for creative photography.

Exposure

Cameras today have very accurate metering systems, which have the following metering modes:

Average: Light level is averaged from the whole scene. Sufficient for a general scene, but does not take into account the principal subject.

Centre-weighted: Similar to average metering but the values are biased towards the central 40 per cent of the view. This is particularly useful for general landscapes and full-face portraits.

Matrix/multi-segment: An advanced metering system that takes light readings from different parts of the scene and combines them to produce an overall reading. The exposure meter's computer can compare the readings from the separate zones and produce a very accurate overall assessment. This mode is found on most SLRs and is used by many photographers as a default setting.

Spot: Takes a reading from a small 'spot' – usually a region in the centre of the viewfinder, approximately three per cent of the total view. A light reading will need to be taken off the subject when using spot metering and compensation must be applied. The exposure setting can then be locked and the shot recomposed with the accurate exposure.

For a more accurate light reading many photographers use a reflected light meter, a hand-held device, aimed at the subject from the axis of the camera lens. This helps to evaluate the range between the areas of light and dark on the subject. Meters have no way of knowing whether a subject is predominantly light or dark. This can, if the exposure setting is applied directly, lead to incorrect exposure of film. For this reason it is often better to look for the darkest and lightest areas of the subject – take meter readings from both, compare them and set the meter to translate the meter reading midway.

If a proper assessment of the exposure cannot be made, exposure can be bracketed. Take one shot at the exposure settings suggested by the meter. Then take another with the exposure increased by half (or maybe a third) of a stop; another with the exposure increased by one full stop. Do the same by decreasing the exposure. Unless you are very unlucky, one of the images will be perfectly exposed. This is known as exposure bracketing; many cameras today have an auto-bracketing feature that will shoot off a sequence of shots with one press of the shutter release.

Film processing

Film processing is a crucial stage in the photographic workflow leading to the production of prints. Most photographers will have invested a lot of time and effort – and sometimes considerable cost – in shooting original images. Any fault at the processing stage can render all effort in vain so it is essential that photographers are fully conversant with both the general procedures and specifics of film processing.

Film processing procedure

All film must be handled in complete darkness once out of its canister. The most common method of professional film processing is the 'dip and dunk method', where the film is dipped and dunked into large tanks of chemicals. Some professionals and enthusiasts process film in small batches using smaller tanks or cylinders. This method involves loading film on to spirals constructed of plastic or stainless steel, stacked together and sealed into the container with a light trap for filling and emptying chemicals. This allows for the film to be processed in a lightroom once loaded.

Film needs to be wound on to a reel before processing. The most popular type of reel is the stainless steel variety with the clip in the centre axle. This holds the film better and is easier to keep clean than the plastic Paterson bearing type.

Once the film is out of its canister or spool, have the spiral in one hand and curve the leading edge of the film between your thumb and forefinger in the other. Guide the edge into the clip and start pulling the reel and film around so that it loads evenly into the reel. If loaded correctly, the film should feel loose on the reel. If not, slowly unwind the film back and start again. This procedure takes practice, but becomes easier with experience.

Practise loading film in the light using a dummy roll in order to get used to the feel and tension of the reel and film. If you are using the Paterson plastic type of reel, feed the film through the ball bearing registration lugs and slowly rotate the ends of the spiral with a twisting motion and the film should feed on, ready for processing. This job is harder – sometimes impossible – if the plastic spirals are wet or damp, so it is important to ensure that the spirals are thoroughly dry before starting a darkroom session.

'Thanks to my effort in the last 40 years, there has been more paper and film wasted. '
Man Ray

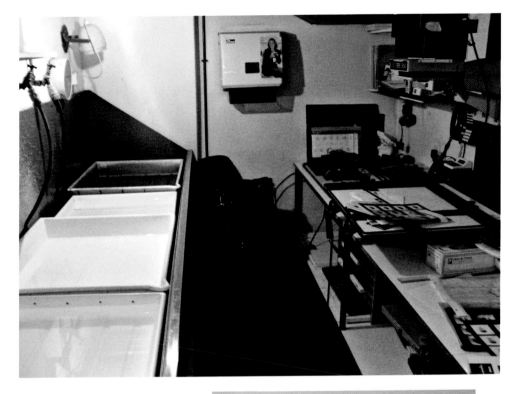

Black-and-white darkroom
A view of a typical darkroom
layout together with some of the
associated printing tools.

Possible problems in loading film

Common mistakes may appear as horseshoe-shaped marks or kinks in the negative. These indicate that the film has been handled roughly or loaded unevenly. White or blank areas on the film are due to undeveloped areas where the film surfaces have touched during processing and the chemistry has been unable to work on the emulsion. 'Bromide drag' is another problem in 35mm film processing. It is characterised by streaks or unevenly developed areas opposite the sprocket holes. This can be a result of under- or over-agitation, and is likely to be related to the dissipation of soluble potassium bromide in the developer solution, which when added to the developer's own bromide restrainer, can retard the developer action. Pre-soaking film will help alleviate this problem, as will proper mixing of chemicals. Sometimes a developer solution mixed prior to processing can be too active and it is best to let it stand for 24 hours before use.

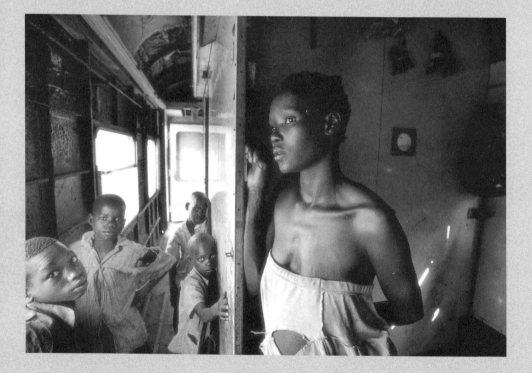

Margaret Aber, Lira (above)

The photographer encountered the subject and her children on an abandoned train on the outskirts of Lira, Northern Uganda. Like many others she had lost everything and fled to the area as the war unfolded.

Photographer: Alixandra Fazzina.

Technical summary: Ilford HP5 35mm film rated normal, processed at +1/2, printed on Ilford Multigrade Warmtone Semi-Matt paper.

Developing film

When film is exposed to light a tiny electrical charge alters the silver halide grains and makes them receptive to the chemicals in the developing process. The developer – the chemical responsible for developing the film – is a complex mix containing the following:

Developing agent: Responsible for reducing the silver halide to metallic silver. Common chemicals used are metol, phenidone and hydroquinine.

Preservative (such as sodium sulphite): This reduces the rate at which the developer combines with oxygen from the air; without this the developer could become unuseable within a day or two.

Alkali accelerator: This controls the contrast of the image developed on the film. Typical chemicals that achieve this are borax, sodium metaborate, sodium or potassium carbonate or sodium or potassium hydroxide.

Restrainer: This slows the rate of development so that the photographer has more control over the duration of the development process. It is normally potassium bromide.

When using a new film or developer it is important to follow manufacturer guidelines for the combination. Contrast can be increased by pushing the film and using longer development times. The effect is to create a negative with a higher maximum density and a slightly higher minimum density (often seen as base fog and milkiness in the film base). Pulling a film and using shorter development times will produce lower densities throughout. Using a different developer, one designed for downrating, such as Kodak HC110, can have a similar effect. This allows film speed to be reduced without sacrificing contrast.

A thin negative is produced as a result of the subject being underexposed, making the shadow areas compressed. If this happens, expanding the development time can marginally improve the higher and mid-tone values. The same principle is applied to negatives that have been overexposed: by pulling the development time, density values of the negative can be decreased. This is why photographers generally follow the maxim 'expose for the shadows and develop for the highlights'.

It is important to implement discipline when it comes to processing film. Once film has been damaged it is difficult and costly to try and rectify mistakes. Good darkroom practice is essential. Work out the time required to develop your film and build in the times that are required for agitating the tank throughout the process. Always use a clock with an indicator alarm, which indicates when the time is nearly up. It may be a good idea to pre-soak film before processing, as this will help to alleviate streaking and uneven development. As the gelatin layer of the emulsion swells it will be more receptive to chemistry. Always pour chemicals into the tank or submerge the film in open tanks in a smooth manner.

Developers

Periodic agitation is required during development so find a method that works to your satisfaction. When using small tanks or cylinders it is common to invert and twist the tank in one movement, taking five seconds to complete the action. Never over-agitate or shake tanks, as this will create pockets of air and bubbles that will affect the film development. Try agitating for the first 30 seconds, and then for 10 seconds every 30 seconds throughout the development time.

Although film developers will not affect the size of the silver halide grains on film, they can affect the appearance of the grain once it is processed. Manufacturers often recommend particular developers to match film. Generally there are three types of developer available:

Standard developers: General use developers that provide good tonal range with high acutance, including Kodak HC-110; Kodak D-76 and Ilford ID-11.

Fine-grain developers: Contain sodium sulphite, which acts as a solvent when it comes into contact with silver halide. This will not alter the silver grain size, but may reduce the grain acutance, making them appear smaller. Using this developer also lessens the clumping together of developed grains. Try Ilford Perceptol, Rodinol, and Kodak D-23 or D-25 formulas.

High-energy developers: Manufactured with strong solutions, which when used effectively reduce the silver halides completely down to metallic silver. This is particularly useful if film has been underexposed. Try Kodak D-82 formula.

Once the developing process is complete it will need to be stopped. A stop bath can be used to do this – an acidic solution that neutralises the alkaline developer. It also helps to extend the life of the working fixer. Use the stop bath for 30 seconds to a minute and then discard. Stop bath is cheap and there is little need to recycle.

standard developers developers providing good tonal range with high acutance
fine-grain developers developers containing sodium sulphite, which acts a solvent; this developer lessens the clumping of developed grains
high-energy developers developers manufactured with strong solutions; reduce silver halides to metallic silver

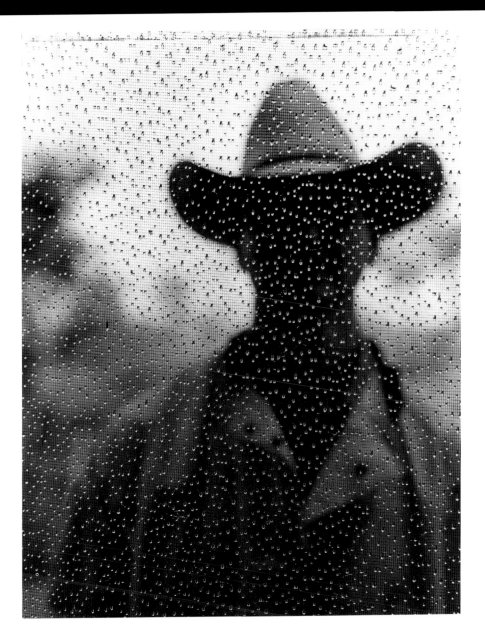

Jeff Haley, Texas (above)

Unlike conventional film Polaroid Type 55 provides the photographer with an instant negative and positive. Once 'processed' the negative can be used directly in the enlarger to produce fine prints.

Photographer: Jon Nicholson.

Technical summary: 5'' x 4'' Polaroid Type 55, printed on Agfa Multicontrast FB, with a slight selenium split tone.

Fixing, washing and drying
After the stop bath, a fixer can be applied to the film. The fixer removes any undeveloped silver bromide, which could turn black and contaminate the film. Care must be taken when handling fixer. Manufacturers' recommendations must be followed – a fixer that is too weak will not be effective enough and fixer that is too strong can cause sulphating of the silver, which appears as a bleaching of subtle highlight detail.

Once the fixer has done its job it needs to be thoroughly washed from the film. Any residue can compromise film quality and cause long-term damage. The most effective way is to wash film in slow running water at about 20 degrees Celsius for around 30 minutes. It can then be rinsed in water containing one or two drops of wetting solution. This is a mild detergent-based chemical that minimises the risk of water droplets clinging to the film and leaving marks while it dries.

Following this, the film needs to be dried. This is the stage where film is at its most vulnerable: the emulsion will be both soft (so can be easily scratched) and sticky (making it likely to attract dust). Use a purpose-built drying cabinet for drying film, as this provides a controlled and dust-free environment. If this facility is not available, hang the film in a dust-free, clean space. Once dry, the film is ready for bagging into sleeves and will then be ready for the first printing stage – contact printing. Contact sheets show the quality of the photographic images.

The contact sheet
Before making prints from individual film negatives, the best images must be selected. The simplest way to do this is to produce a contact sheet. This allows for a general overview of the film where exposure, focusing and composition can be checked. The contact sheet can also serve as a future reference for archiving negatives; cropping and exposure notes can also be written on the contact sheet. The contact sheet is also a very useful tool for showing others your work and discussing a brief about printing. A well-exposed and well-presented contact sheet leaves a prospective client with a good impression.

The easiest way to make a contact sheet is to lay the photographic paper on to the baseboard and expose it under the enlarger with enough light to cover the whole surface area of the paper. It is recommended that the enlarger height and contrast filtration be standardised so that contacting can become a measure of how thin or dense negatives are compared to other material that has been shot. Contact print frames can be purchased from most photographic outlets, but a scratch-free piece of glass taped to the baseboard is sufficient. Under safelight conditions the negatives are sandwiched between the glass and the paper. A test sheet is made by exposing sections of the sheet in five-second increments; the paper is then processed in the normal manner. Once the optimum exposure has been judged, a full sheet is exposed and the process continues. It is usual for different frames to demand different exposures and with practice, it will be possible to block or flag frames on the contact sheet. This will provide a balanced contact sheet, allowing clear analysis of the image composition.

Black-and-white contact sheet
A typical contact sheet showing frames and frame numbers for easy reference and identification.

Digital image files

It is difficult to draw precise parallels between film and digital files. Digital memory cards – the cards used in digital cameras to store image files – are often described as 'digital film'. To a point, this is a good analogy, but a memory card really is just that: a card upon which data can be stored. The card itself does not affect the quality of the image stored, nor does it have any other impact in the way that different film emulsions do. The distinctions in digital images are due to the format in which the image data is stored. This section will look at different digital formats, but will first offer a basic overview on the role played by the memory card.

Memory cards

Memory cards provide a convenient way to store data and to physically transfer it from one device to another. Memory cards are much smaller than floppy discs yet their capacity for storing information is much higher. Many cards now offer capacities as high as 8GB, with larger ones on the horizon.

There is a wide range of memory card types available. Some offer smaller form sizes, others are 'faster' (that is, the speed to which data can be written to them is higher), but any decision as to which card to use is probably going to be dictated by the camera it will be used with. The most common format of card used by professionals is the CompactFlash. Although an older design, it remains popular because it has kept pace with developments in memory size – it offers one of the highest memory card capacities. Cards also contain some subsidiary electronics that can make data recording and transfer extremely fast. Memory cards have proven to be very reliable devices and their failure rate is low. However, the fear of failure or accidents means that many photographers are more likely to carry, say, four 2GB memory cards rather than a single 8GB, in order to spread the risk.

File formats

As mentioned previously, although memory cards are important, it is the file format which determines the quality of the images. The list on the facing page includes the various types of file formats, describing their characteristics, advantages and disadvantages.

'Look, I'm not an intellectual – I just take pictures.'
Helmut Newton

RAW: This is the format that will – ultimately - provide the optimum image file. When 'RAW' is selected for storing files, the output from the sensor, with just the most minimal intervention on the part of the camera electronics, is stored. Files can be up to six times the size of a typical JPEG format (which we look at next) because the file is not compressed in any way. Because the image is essentially unprocessed, additional software must be utilised to convert the image into an RGB image. Most image-editing applications include such conversion software although it is worth pointing out that there is no standard for RAW files and each manufacturer has their own interpretation of the format (this is indicated by a unique file extension or suffix). Another drawback in some cameras is that because the data in the file is so basic, it can't be displayed as a post-view image on the camera's LCD. Some cameras get around this shortcoming by also saving an alternative JPEG version of the image.

JPEG: A standard file format devised by the Joint Photographic Experts Group (ISO industry approved in 1994) and the most common method of file storing. Files are compressed before being saved to a memory card (generally by a factor of around 10), which allows more images to be stored on a given card. However, this image compression does result in data being lost (it is known as a 'lossy' file format) and the restored image will not be as accurately defined as that from a format that is lossless (such as RAW or TIFF). Degradation increases the more times an image is saved and retrieved, resulting in artefacts appearing in the image as pixelation, which can be difficult to remove.

TIFF: The Tagged Image File Format is a file format that offers a good compromise. It uses a lossless compression method, which means there is no loss of image quality when an image is saved in this format. However, file sizes are somewhat larger than those offered by JPEG. This may have ramifications for those who need to shoot a large number of images in a short sequence. Like JPEG, TIFF files follow a common format that allows the files to be widely shared.

Virtually all digital cameras will offer at least one of the formats outlined above. An increasing number offer two or even all three. Other common formats found in the imaging industry include IVUE, DCS, EPS but these are rarely encountered in digital cameras. The same may be said of the following formats, although it is worth spending a moment describing each:

GIF: Primarily used in the web graphics industry, GIFs use only 256 colours.

PICT: A Mac-based format that can provide RLE (good compression for images that use predominantly plain background colours).

BMP: A Windows-based system that supports large and uncompressed files, commonly 24- or 32-bit colour images, although using RLE lossless compression will provide file sizes of four- and eight-bit size.

PDF: This is the common Portable Document Format, often used for document layout that includes text and images. Run by Adobe, it is often used for downloadable files, magazine and book publishing.

File organisation and management

As with film and negatives, a filing system is necessary for digital files. However, there won't be an obvious and tangible product so any regime for storing and managing images needs to be comprehensive, and must provide a way of easily identifying, viewing and retrieving specific images. First, images must be taken from the camera's memory card and loaded on to the computer. Most cameras come with basic management programmes that can be used for transferring images to a hard drive. There are also several DPM (Digital Photo Management) programmes that provide expanded managing and cataloguing methods.

From the outset it is worth considering a strategy for storing all your images. Most digital camera users find that they shoot and retain far more images than they used to when using film, so it is important to be able to keep tabs on all of them. When an image is downloaded it will have a unique code number that will not relate in any way to the subject, so try to add captions and keywords to all images. Although this may seem laborious, captions and keywords will make it immeasurably easier to find certain images later. Also ensure that when renaming files, the original metadata EXIF information is not removed. This data is automatically appended to every digital file and includes the camera settings, file information and any thumbnail attachment.

Software applications for file management

Several applications are available for managing file libraries. Applications such as iPhoto on Macintosh are free and have good basic methods of file management. A similar system now exists for Windows users. These applications are not, however, designed for demanding or professional use, and may not offer the degree of control and organisation that these users demand.

Popular amongst professionals are applications such as Extensis Portfolio and ACDSee. These offer expanded features suited to refined subject storage and recall. These programmes provide detailed captioning, tagging and subject listings. As the library builds and specific areas or subjects grow, files can be further subdivided into folders. Doing this helps to identify key areas of interest and also allows the user to click and drag images from folder to folder, which is particularly useful for working with images in various categories or portfolios.

Apple have an application called Aperture, which allows for fast file transfer workflows and is particularly useful for those that shoot using the RAW format. In addition to this is a unique programme called iWork, which allows users to create their own slideshows and presentations in the Keynote application. Keynote allows images to be dragged and dropped from the original library and then used to create presentations with text and movie attachments, without losing the original material's location.

Photoshop file browser

A typical file browser
pop-up window.

Library listings

Library listings aid in the storage
and retrieval of digital files.

Aperture slide browser

A typical working Aperture
pop-up window.

International Press Telecommunications Council (IPTC)
A typical file management application might work like this: once a file is opened from the document or hard drive folder, a pane will appear, providing a general summary of that particular file. Drop-down menus provide details of how the file is currently stored and may include the file title, format, size and dates of origination and modification, if available. You can also rename the file here, as well as make rudimentary changes to highlight the file. Photoshop allows for more detailed changes to be made to a file from the 'File Info' drop-down menu. Sections such as 'General' or 'Categories' can be used to make cataloguing changes, write author notes, provide keywords and add other details relevant to the image.

All of this ties in with the International Press Telecommunications Council (IPTC) standard requirement, which most picture agencies and press associations adhere to. It is important to find a system of filing that works for your type of photography. If you are considering using an agency it is important that image files are tagged clearly and meet the technical specification of the chosen agency. If, on the other hand, you are building a project over time it is important that your project albums are accessible; the same consideration must be taken when constructing portfolios or slideshows.

**Photoshop File
Information panel**
More accurate detail can be
stored using the file information
panel option.

Keynote
A typical Keynote pop-up window.

'Everyone has a photographic memory, but not everyone has film.'
Anonymous

St Paul's Cathedral on fire during the Blitz (above)

Taken at the height of the Blitz, this image is synonymous with the bravery and resolution of the Allies during The Second World War. The Photoshop File Info pop-up shows the basic file information for this image.

Photographer: Keystone.

Technical summary: Taken from a scan of the original print.

Workflow management

From the onset, it is extremely important and helpful to sort and analyse digital image files. This is a stage that can be, very roughly, equated with the production of a contact sheet for conventional film. The traditional method's equivalent in digital photography would be for a photographer to do a basic assessment by scanning images in a cataloguing or management application (such as Portfolio, which was discussed earlier). Then, using an image-manipulation application such as Photoshop, general corrections would be applied to one image and the same corrections, saved as a macro or droplet (a series of commands that can be applied in a single sequence), applied to other images as necessary. The last few years have seen new applications designed for professional workflow management. The two main ones are Aperture from Apple (a Macintosh only application) and Photoshop Lightroom from Adobe (Windows and Macintosh compatible).

Using either one of these applications, a structured workflow can easily be followed:

1 **Import:** Immediately download (from your cameras, memory cards or another location on your computer) your images and organise them. You can add tagging information as you go along.

2 **Manage images:** Using the library view, organise images into individual collections. You can also browse and compare images, adding additional keywords if appropriate and relevant.

3 **Develop:** A curious term for digital images, but this is where you can apply global corrections to your images. This includes applying adjustments to exposure, neutralising or enhancing colour casts or adjusting the white balance so that white and neutral-coloured objects are accurately rendered.

4 **Presentation:** With all the corrections made you can now produce high quality, high resolution contact sheets or slide shows of your digital images. Slide shows, particularly, are designed for impressive client presentations.

'Bad, rich amateurs think fuzzy black-and-white images of poor people are art.'
Ken Rockwell

Working with scanners and scanned images

Apart from using digital files direct from the camera, the other method to prepare files for post-production is to scan from film or paper original. Somewhat controversially, many photographers say that scanning film is still the best method of producing a digital file. Kodak in particular have embraced this by introducing a film range – Portra – specially designed for scanning. Whereas Chapter 1 looked briefly at scanning equipment, here, we look more closely at the options available for producing digital image files from film originals.

Flatbed and desktop scanners use a moving, three-colour RGB CCD sensor, which passes below glass on which the object is placed. Some also come with a transparency attachment allowing for the scanning of negative or transparency. When choosing a desktop scanner the maximum resolution and the dynamic range (d) are important considerations. The dynamic range is a measure of the scanner's ability to record the tonal range: the higher the d value, the greater the range of tones and brightness the scanner can record.

The maximum optical resolution that a flatbed scanner can provide is 600ppi. Some manufacturers claim to have scanners that can reproduce images at 9600ppi, but this is an interpolated amount, and the highest optical resolution available when using a high-end CCD scanner is 4800ppi. The Hasselblad Flextight film series of scanners are easy to use and offer up to 8000dpi resolution from 35mm originals. They also have a very good dynamic range. Being upright they take up minimal space when compared with other high resolution scanners. Professional drum scanners use photomultiplier tubes (PMT) as their sensors. The original object, film or paper is mounted on to the drum, held between sheets of acetate; the drum rotates at high speed passing in front of the optics that then transfer the information to three RGB-matched PMTs. This is the primary method of scanning film and offers resolutions between 8000–14000ppi.

Dust removal and sharpening techniques

Most scanners have a dust removal facility built into the system, which digitally removes the dust from the image files. Dust removal packages, such as Digital ICE and Canon's FARE, are also available and operate by making a second scan with an infrared beam. This maps a 3D sample of the film plane, so that dust particles can be identified from the actual film surface, which are then blended by a separate software programme.

As with dust removal systems, scanners also come with a sharpening feature, which can, at times, be rather crude. Most photographers switch this feature off and apply it at a later stage in Photoshop. The main sharpening tool used by scanners is called the Unsharp Mask. This technique originally used a soft negative version of the image, which was sandwiched with the positive original, resulting in improved edge definition and a much sharper-looking image. The examples on page 60 show two scans: one with the Unsharp Mask option applied and the other without. The scan with the Unsharp unchecked appears softer, but this can be rectified more accurately in Photoshop.

Pixels and image resolution

The following examples are shown together with their Preview panes, which allow for more accurate adjustment of degrees of sharpening – the higher the percentage the greater the effect. The pixel radius measurement determines the width of the sharpening, normally between one and two, and the Threshold level determines how much the pixels are sharpened relative to adjacent pixels. More pixels are sharpened at lower levels and by increasing the threshold edge sharpness becomes more apparent.

Image resolution is the measure of how well a scanning device can resolve an image; it is measured by pixels per inch (ppi). Lower-end scanners provide 600 x 200ppi rising to 3048 x 3048 at the high end.

Dots per inch (dpi) is a measure of printing resolution, which is sometimes confused with ppi and often used interchangeably (and incorrectly!) with it. DPI is the number of dots per inch of ink that can be produced within the linear one inch or 2.54cm space. Different types of imaging device will provide varying capabilities for resolution. An inkjet printer, for instance, would be capable of 360dpi, but a laser printer could do up to 1800dpi. At present, there is an argument to abandon the dpi measurement for a new standard of dot spacing in micrometres or dpcm (dots per centimetre), which would provide a more accurate representation. For the moment, however, all printer manufacturers tend to stick with dpi.

Unsharp Mask box
Screengrab showing typical unsharp options at the image scanning stage.

Unsharp off screen grab
Image with Unsharp Mask switched off.

Unsharp on screen grab
Image with Unsharp Mask switched on.

Unsharp Mask option

Screengrabs showing the various effects of the Unsharp Mask.

Colour management

It might seem incongruous to discuss colour management in black-and-white photography but images tend to be taken and downloaded from a camera in colour. This colour information is used in the creation of black-and-white images and it is important to resist selecting the 'Black and White' option on any camera that has it. This option discards colour information and delivers only lacklustre monochrome images. In this section we discuss the different ways – colour modes – in which an image can be managed, and look at the benefits of each.

One of the most common complaints about digital imaging is that output prints are difficult to match to the image on screen. The goal of colour management is to calibrate and control the working parameters of all the equipment used in post-production to a standard colour space, typically RGB or CMYK – also known as the 'gamut'. Once this colour space is established, each item of equipment can be calibrated to match it, thus assuring consistency of colour throughout the process.

RGB is the mode that images are stored in when saved on a digital camera. The colour of every pixel in the image is determined by the relative amounts of red, green and blue. RGB mode is described as an 'additive model' because the components of each colour are effectively added together to produce any final colour. It would be impossible for a monitor to recreate every colour possible in nature (although they can come very close) so a 'gamut' or 'colour space' is defined to describe colour that falls within a range of between 0 and 255.

In Photoshop the red, green and blue channels are each described digitally by an 8-bit number. Combined, this produces 24-bit colour (three 8-bits) with the capacity to create 16.7 million colour combinations. All images used in Photoshop will be assigned one or more channels, depending on which colour model is being used. Black and white, greyscale and duotone have only one channel in place of RGB's three.

Blue

Magenta

Cyan

Red

Green

Yellow

Diagram of RGB
A typical RGB diagram showing the gamut or colour space range. RGB is an additive colour model so that elements of red, green or blue can be added to create any desired colour.

CMYK mode is a subtractive method based on ink and dye media, commonly used in the commercial printing industry for books and magazines. All images intended for print, regardless of whether they are created in RGB, will be converted to CMYK for printing. CMYK is made up of cyan, magenta, yellow and, to ensure greater clarity, black (corresponding to the 'K' in CMYK). CMYK has a narrower range of colours that can be displayed, and particularly garish colours often step outside of the colour gamut or range. Because of this there will be a difference in how RGB and CMYK images are displayed and reproduced. In order that the differences can be viewed prior to committing to print, image-editing applications like Photoshop can identify those colours that will not be accurately printed and show them on screen. They appear highlighted when you select the 'Out of Gamut' warning.

In recent times much of the responsibility for converting images for publication to CMYK has been passed from the printing house back to the image-maker. Many professional laboratories now offer a proofing service where RGB files are converted according to a publisher's profile so that a direct match can be achieved for a specific publication.

Ugra/FOGRA-Medienkeil CMYK-TIFF V2.0a

CMYK profile strip
An example of a CMYK profile strip, which is used to calibrate and monitor screen to print calibration.

Diagram of CMYK
CMYK is a subtractive model for creating colour, which is common in repro houses, printing presses or publications. It is also used to proof images before passing on for repro.

Yellow

Green

Red

Cyan

Magenta

Blue

Colours and calibration

An **IT8 calibration target** can help to ensure that a scanner and camera see colours in exactly the same way. Devices are calibrated using a reference colour scale. The IT8 colour target provides industry-set colour and greyscale parameters. Most scanners have an automatic setting, which, on the whole, produces acceptable images.

However, colour casts and bias are not uncommon and could be the starting point for frustration! Scan the IT8 target as an RGB file with no adjustments and import it into the management folder so that it can be compared to the reference file. The software will make the comparison and any adjustments can then be saved as an **ICC colour profile** relevant to that scanner. In practice images can be scanned in with no adjustments and a ready-prepared profile can be applied in Photoshop. Remember to convert the image back into the colour space that you are currently working in.

It is important not to make the mistake of investing in a decent printer and then use it with non-compatible or inferior media with which to print on. Ink and paper consumables are very expensive in comparison to photographic types of media, so use material that is recommended by the manufacturer. By using the same IT8 target sheet you can print off the sheet, scan it and match it to the reference file as before and make adjustments to suit. For more accuracy, the colourimeter or spectrophotometer can be used as with monitor calibration. Print out the target sheet and compare each patch to the reference file, again making the adjustments to create your own profile for when you print.

IT8 calibration target a standard which ensures that a scanner and a camera see colours in exactly the same way

ICC colour profile the International Colour Consortium's widely used specification for various colour management systems

IT8 target

An IT8 target diagram showing
the measurements used to
calibrate screen to output media.

Profile drop-down menu

This allows a working ICC profile
to be applied to the file. We most
commonly use Adobe RGB (1998)
for imaging.

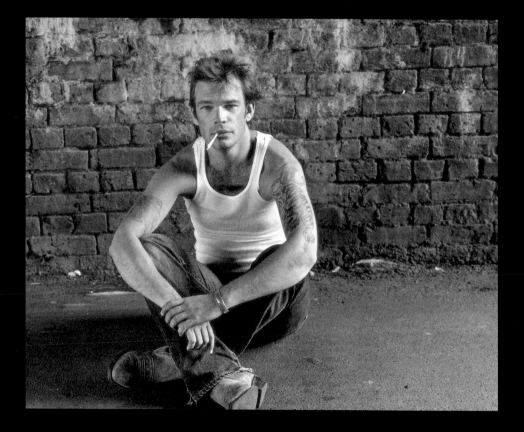

Whether digital or conventional, it is rare that an image taken directly from the camera delivers a perfect end product. Whether that end product is to be a print, a series of prints or perhaps a set of images destined for a website, it will need to undergo a degree of manipulation to produce the best possible results. There are obvious differences between digital and conventional image manipulation techniques, but there is much that the two have in common. This chapter will present an analysis of the procedures employed by both methods in order to create stunning images.

'To manipulate an image is to control a people.'
Carolyn Gerard

Male model (facing page)
This image was taken from a project on male models, after their modelling careers. Pictured is Billy White from the Levi's Jeans advertisements in the 1980s.

Photographer: Deirdre O'Callaghan.

Technical summary: Kodak TRI-X 400, rated at normal, processed at +1/2, printed on Ilford Warmtone Semi-Matt paper.

Making a basic print

The previous chapter looked at the stages of photographic processing leading to the production of a contact sheet. Contact sheets enable the photographer to assess which of the many images that have been shot are worthy of enlargement. A contact print is a good way of getting an overview of all the images on a roll of film, but it is important to keep in mind that all the frames on the sheet receive equal processing. This may not then show each and every frame in the best light possible.

An assessment of a contact sheet needs to be more circumspect: images that are not sharp enough (unless shot that way for creative reasons) need to be discarded along with those significantly over or underexposed. Shots that are only slightly lighter or darker than average need to be more closely examined before being shortlisted for further work. When moving from the production of contact prints to enlargements, the rules and guidelines for good practice and processing are exactly the same.

Before the enlarger head is adjusted to the height required to produce an image of a particular scale, ensure that the easel is adjusted to the size of paper to be used, and the right borders and margins have been set. This is something that most people often overlook and it usually results in badly placed images. Enlarger heads can now be adjusted to allow a print of the required size to be produced in focus, so that the grain structure in the image is both visible and sharp. An inexpensive focus finder will help achieve this, although professionals – who need to ensure critical edge-to-edge sharpness – will often invest in a more precise (and more expensive) device. When adjusting the sharpness, it is crucial to ensure that the level of sharpness is the same across the image. It is important to regularly check the enlarger and its baseboard alignment as it can occasionally become misaligned, which then affects image sharpness.

The test sheet

After producing a contact sheet – which is principally done to assess the pictorial value of selected images – and before producing the first enlargements of those images, it is important to produce a test sheet. This print will be the basis for final prints and it comprises of strips with progressively longer exposure times. This enables proper assessments to be made on the exposure required for the final print.

Consider the test sheet as the foundation of the printing process. Once this has been made and correctly assessed, everything else in the print production process should fall into place – a good test sheet is one that reveals a starting point for considerations of density, contrast, image sharpness and composition. It is adviseable to use a whole sheet of paper for each test print as it will reveal more about the image and, more particularly, it will confirm whether the sharpness and composition are up to the mark.

When producing a test print, particular consideration must be given to the exposure. Determine from the contact print where the most important areas of the print will be so that, when it comes to making the test sheet, that area will fall into the exposure zone.

Process the paper in the same way as the contact sheet. Assessments on how the final image is going to look can then be made. If using **resin-coated (RC) paper** the test print can be viewed while still damp, but for the more traditional **fibre-based (FB) papers**, you may have to wait until the print is dry. FB paper characteristically looks different when wet to when it is dry due to shifts in contrast and density in the drying process. With just a little experience, it is soon possible to assess the differences in an image when wet and when dry in order to make an objective judgement on a wet print.

When making judgements on how the final print will look, consider contrast, density, the overall feel of the image, and where manipulations will need to be applied. The principal objective in assessing a test sheet is to accurately determine the fundamental exposure of the print. It is also useful for understanding the way the developer chemistries work; consider if any special approach to the development process needs to be applied. It is at this point when the Levels and Curves applications are used to control and influence basic image balance.

The basic print
When the basic exposure has been determined, the contrast of the image needs to be decided. Opinion tends to be divided on the best way to assess this. Some photographers produce a second test sheet, and instead of varying the exposure time they vary the contrast filtration. By varying the filtration different contrast levels can be produced.

Filters can also be added to the enlarger head to control the contrast in the photographic paper. On a test print the filters would be varied as the different parts of the image are exposed. Other photographers find this approach too prescribed and too mechanical. With a basic understanding of contrast effects, a basic print at a pre-assessed contrast level can be made. This print can then be closely assessed before determining whether this level is correct or needs modification.

resin-coated (RC) paper a type of photographic paper where one side is coated with light-sensitive silver particles suspended in polyethelyne, making the paper base waterproof and easier to wash
fibre-based (FB) paper a type of photographic paper where silver particles are embedded into the cotton fibre of the paper; the design means the image becomes part of the substrate, giving the print a longer lifespan

Steps, Thurso Beach (below)

The two images below show the test print and basic print for the final print of Steps, Thurso Beach (see page 75). Notice the various strips on the test print, which illustrate the varying degrees of exposure.

Photographer: Steve Macleod.

Technical summary: Ilford Warmtone Semi-Matt paper, Grade 2 1/2, F11.

Test print

This example shows the whole test sheet exposed to a graduation of exposure in five-second increments, building up to find the optimum starting exposure for a working print.

Basic print

Based on the test sheet's results, an exposure of F11, on Grade 3 paper for 15 seconds was used. The wall on the right-hand side was covered during initial exposure as it was too heavy; exposing it for the same amount of time as the rest of the image would have resulted in an imbalance. The print was balanced with some burning in of detail after the first exposure.

Fixed-grade (FG) and variable-contrast (VC) papers

Contrast control is an important aspect of producing a competent print and we should spend a little more time exploring it. Photographic papers are not only distinguished by their base or coat (fibre-based or resin-coated) – they can also be classified according to the contrast they provide. There are two papers that fall into this category: fixed-grade paper (FG) and variable-contrast paper (VC).

FG papers are much less common than they used to be as many VC papers have now become the industry standards. The older, fixed-grade technology demanded that if you wanted to produce prints with different contrast levels you would need to stock up with a range of papers, each offering a slightly different contrast grade. If you produced a print with a certain degree of contrast and wanted to reprint it with a higher or lower contrast level you would need to use a different paper grade. It is difficult to find all FG papers available in all contrast grades. They come in precisely determined grades from the manufacturer and are graded from 0 to 5 – 0 being softest in contrast and 5 being the hardest, providing the most contrasting prints.

VC papers allow different contrast levels to be achieved with a single type of paper. Different grades of contrast – equivalent to those provided by different fixed-grade papers – are achieved by dialling in different filtration levels, or adding different filters through the enlarger. The paper uses multiple layers of emulsion that are sensitive to slightly different coloured light, enabling a single sheet to replicate every contrast grade. They can also replicate intermediate steps, which allows for more control. The contrast grade is adjusted through the balance of blue to green light in the enlarger filters: one layer of emulsion in the paper has a sensitivity to blue light, and another is sensitive to green/blue light. Therefore, by adjusting light filtration through the enlarger the emulsion sensitivity can be altered. Images can also be exposed using various filtrations on one sheet – this is known as split-grade printing.

Author's tip

Often, the relationship between photographer and printer becomes an integral part of the process, driving the common bond and understanding in communicating the photographer's ideas into this two-dimensional object. This really is where the magic starts to happen; the printer's own subjective appraisal of an image will be far different to that of many clients, but by creating an understanding and utilising objective decision-making processes, it can be said that there is no single 'correct' print. We each have our own tastes and fundamentally it is crucial to learn what that taste is and to translate it into our work – that is, ultimately, what we think makes a great print.

Grade test prints (below)

The following examples illustrate how changing the filtration grade of paper alters the feel of the image. The lower grades show more tonal range and relative softness, whereas the higher grades appear more graphic in nature. As a rule of thumb, consider starting a basic print of this image at Grade 2.5 or Grade 3.

Photographer: Steve Macleod.

Technical summary: Variable-contrast papers, Grades 0–5, no other details recorded.

Grade 0

Grade 1

Grade 2

Grade 3

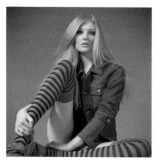

Grade 4

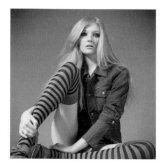

Grade 5

Grade 0: There is a lot of tonal detail even in the extreme highlight of the window. Overall the image appears very flat and lacks contrast.

Grade 1: There is a deepening of the blacks and shadow areas and the highlights are lifting.

Grade 2: Contrast has started to separate the shadow from highlight, and the tones are giving the impression of being compressed together.

Grade 3: The contrast increases and the texture of the model's face and the wooden background appear three-dimensional.

Grade 4: The image tones are becoming more compressed, losing subtlety.

Grade 5: The image has lost substance and has become very black and white and two-dimensional.

Exposure compensation

Like film, different manufacturers' papers will have slightly different light sensitivity. Often, even changing between an RC and FB version of the same paper type will affect the image contrast and speed. Also the higher grade VC paper – Grades 4 and 5 – have their sensitivity effectively reduced, as the filters used to control the contrast at this high level reduce the light output of the enlarger. As a guide, the exposure compensation for Grade 4 should be half a stop increase of that applied for Grades 0, 1, 2 and 3.

If using Grade 5 paper the exposure should be increased by a full stop. Do bear in mind, however, that this does vary according to the paper type and brand, so it is prudent to test with each type of paper used.

The weight of a paper and its tactile quality will also alter depending on whether it is single-weight (SW), double-weight (DW) or triple-weight (TW). Papers have an individual surface texture, ranging from super-fine to canvas and stipple texture. This texture will affect the maximum density of black – the D-max – that can be achieved by any given paper. In general, matt papers absorb light more yet deliver less dense blacks, whereas gloss prints appear to have richer and deeper tones.

Dodging and burning

When a photograph is shot and then printed, the photographer is working with very objective resources. Cameras shoot a scene as they see it. When the negative is printed, the print will reflect that objectivity too. Corrections can be applied to both stages to modify the exposure and the contrast, but essentially a basic print is nothing more than a clinical representation. To convert an image into something more personal, evocative or even more artistic, it must be manipulated. The exposure and, perhaps, contrast can be altered on a localised basis in order to enhance the details and create an ultimately more powerful and effective image. This is done by dodging and burning.

Before attempting to dodge and burn, make assessments and decisions about exposure and contrast when looking at basic prints. Look for areas that are either too dark or too light (or both), which make prints look unbalanced. Print may also be flat, which is characterised by the absence of punchy blacks and brilliant whites, and dominated by shades of grey. More significantly, when making a basic print you may be working with a negative that has a range of brightness levels, which is too wide for the printing paper to record accurately. When correctly exposing for the mid-tones, the highlights are lost and reproduced purely as white, while shadow areas are reduced to black – details in the original negative are lost.

These above examples are all cases where a command of dodging and burning techniques will help to produce effective prints. You can hold back (dodge) areas that are overexposed or add more exposure (burn-in) to areas that are too light. Most photographers and photographic printers have an assortment of dodging tools and this could include pieces of opaque card attached to thin wire, which are effective tools for localised dodging. However, many swear by using just their hands and fingers, which control the amount of light falling on the image.

Dodging tools can be purchased commercially and are available in many different shapes and forms. However, they can be easily made at home as well. Small pieces of cardboard or plasticine moulded on to the end of thin wire, or translucent sheets of film and tissue can all be used. Ensure that the wire is not too thick or it will create a shadow of itself – something that is difficult to remove.

There are different schools of thought on the mechanics of dodging. Some proponents suggest keeping the dodging tool moving during the exposure to avoid creating harsh and obvious edges. However, this could mean less accuracy. Others prefer to keep the dodger roughly in the same place or to mould the dodging tool around a natural shape or boundary within the image being printed. This method requires more accuracy and runs the risk of leaving a line from the shadow cast by the dodging tool's wire.

Burning uses a different toolset: opaque cards with apertures cut through them. This allows certain areas of the print to be obscured and covered from further exposure. Bespoke tools for burning can be produced by sketching out the image on to a sheet of card placed on the baseboard, and then cutting out the appropriate sections. If you are unsure as to where things are on the baseboard, do a dry run without paper; this will help you understand all the elements of the image and the order in which you can do each part of the operation. Alternatively, place a thin piece of card in the easel and sketch the image and exposure notes on to the card. Take a test print, and with a chinograph, draw and write on the print exactly what needs doing – all of these things will aid in understanding what needs to be done to achieve the final print.

Once these methods are perfected, the way a viewer looks at the print can really be controlled. The photographer can lead people around the image, highlighting areas of importance and masking distractions. The aim is to control the elements that combine to make up the final print, and there are no hard and fast rules. The joy of printing is often encountering the unexpected; it is about the manipulation of light and dark. Consistency and being able to replicate printing denotes discipline and understanding of the craft. Do not be afraid to experiment with exposing and developing. It is often useful to compare the final print with a previous work print, so that assessment can be made between the thought processes, imagination and the final reality. Ask questions of working practice to bring the print to a natural conclusion; sometimes it is difficult to break away from an image and to stop perfecting it.

dodging and burning a darkroom technique for lightening (dodging) or darkening (burning) areas of an image by selectively lessening or increasing (respectively) the amount of light the paper is exposed to; this is also the name for the equivalent digital technique

Final print
The contrast of the paper in this final print was increased to Grade 4 and more weight was added to the bottom and top of the image to convey an isolated but anonymous feeling. Digitally the Levels and Curves options in Photoshop would be used to recreate the print's contrast and density (see pages 70–71 for the test and basic prints of this image).

'Great photography is about depth of feeling, not depth of field.'
Peter Adams

The basics of digital image manipulation

The 'digital darkroom' – a computer workstation dedicated to digital imaging – may be vastly different from a traditional darkroom but it owes several of the techniques it employs to traditional methods. The following section will look at how to dodge and burn digital images.

Image sizing

When a large print is needed from a negative, the distance between enlarger head and baseboard is increased. Likewise, it is also possible to specify a larger size digital print in the print dialogue on a computer when configuring for printing. However, just as it is impossible to print a conventional image at any size because the grain structure will become visible – the size of a digital image that can be printed from a file of a given resolution is limited.

The size of an image file can be increased, but as this does not add anything to the image it is not normally recommended. This may be needed in order to produce a particularly large print without the pixel structure of the image becoming obvious and visible. Sometimes a file size may also need to be reduced to produce an image with lower resolution. This may be desirable for an image to be used on a computer screen, where required resolutions are small. As with analogue printing it is good practice to plan ahead, bearing in mind what the final output size of the image is likely to be. This will allow, if scanning an image, for selection of a resolution that is equivalent to that required for the maximum image size likely to be needed. In fact, it is always a good idea to try and provide scans as large as possible.

Should an image need to be enlarged, it is possible to use several interpolation techniques to add extra intermediate pixels. The easiest method is by a process known as **neighbour interpolation**, where each pixel is cloned to produce intermediate pixels. The result is a larger image, but there will be a loss of fine detail as the pixels themselves are enlarged. Another method is **linear interpolation** – an older technique that uses a mathematical method to fill the gaps when an image is enlarged. This method can be applied to photographic images, but it can add a general softening of the image.

Bilinear interpolation is an extension of the linear interpolation method, where pixels are interpolated in more than one direction with new pixels added based on the average of the four pixels in the immediate vicinity of the original pixel. This produces relatively smooth-looking images. **Bicubic interpolation** preserves fine details better than any of the above methods. It involves adding a new pixel using sixteen pixels in the nearest 4x4 neighbourhood. Photoshop CS currently has two variations: bicubic smoother and bicubic sharper. This method is generally regarded as the most successful.

Another method, **fractal interpolation,** uses fractal mathematics to produce interpolated images, which avoid the pitfalls of other interpolating techniques. It is not successful on all images but when it works it can produce some impressive large image files. The best-known product that uses this technology is Genuine Fractals Pro.

In order to change the size of a file in Photoshop (and other similar applications), select 'Image' menu, followed by 'Image Size'. When the dialogue box opens, the 'Resample Image' box is checked, which means that when new physical image dimensions or resolution are entered, the pixel dimensions will alter accordingly. The image resolution can also be altered without changing the physical dimensions of the file. By unchecking the box, the physical size will be changed without altering the resolution. Alternatively, new pixel dimensions can be entered to increase or decrease the image size. This dialogue box also provides the selection method for interpolation, most commonly bicubic interpolation.

Image Size screen grab

The Image Size pop-up menu in Photoshop allows the user to alter the physical dimensions of the image in proportion.

neighbour interpolation a process by which extra pixels are added by cloning each pixel to produce intermediate pixels

linear interpolation uses a mathematical method to fill the gaps when an image is enlarged; it can add a general softening effect to an image

bilinear interpolation an extension of the linear interpolation method, where pixels are interpolated in more than one direction with new pixels added based on the average of the four pixels in the immediate vicinity of the original pixel

bicubic interpolation involves adding a new pixel using sixteen pixels in the nearest 4x4 neighbourhood; this type of interpolation provides the best and sharpest results

fractal interpolation uses fractal mathematics to produce interpolated images

Conversion of colour image files to black and white

There are several ways of converting an image from colour to monochrome. As we have seen, shooting in the black-and-white mode on a digital camera is not recommended as it reduces the amount of control we would ultimately have in creating our final image. Similarly, stripping colour out of an image completely by converting the image mode from RGB to greyscale results in a lacklustre monochrome image. For more successful conversions, it is wise to use something more effective that will enable exploitation of the colour information in an image.

As an alternative, use the Desaturate tool in Photoshop (in Image drop down menu). This allows for colour to be stripped out of a file in order to create a greyscale image; the file size does not change as no information is lost. The Hue/Saturation tool also offers more control. This can be found by selecting Image > Adjustments > Hue/Saturation. Set the saturation to −100 to remove the colour. By ticking the Colourize box, toned prints can be produced very simply. Moving the Hue slider will also alter the colour of the tone.

Many photographers prefer to split images into channels. An RGB colour image is actually composed of separate red, green and blue images. The image can be split into these three channels by selecting the Channels palette and then using the drop down menu to select Split into Channels. When the image is split into channels the single image will be split into three separate black-and-white images. These are equivalent to shooting a standard black-and-white image through red, green and blue photographic filters, and will be distinctly different. In the red channel image, for example, blue skies will be rendered black and skin tones pale; similarly the green image will render green foliage lighter. The blue channel will transform a vivid blue sky into something much paler.

An improved method of conversion is to use the Channel Mixer. This allows the individual channels to get a precise mix of all three. The Channel Mixer uses percentages based on the amount of ink it will take to print the greyscale image, where black is 0% and white 100%. When the Monochrome box is checked the colour is stripped out of the image, but not destroyed. Values of RGB can also be selected and input to create more dramatic effects. To get the best from this method it is worth taking the time to experiment with the variations of the separate channels. This is much like changing filtration grades in the analogue enlarger; predominantly red percentages will increase the contrast of the image, and blue will create flatter tones.

Boris Yeltsin (facing page)

This image was shot as part of Yeltsin's election campaign. This TIFF format image was converted from RGB to monochrome using several methods – as will be seen in the images in the following pages.

Photographer: Unknown.

Technical summary: Not available.

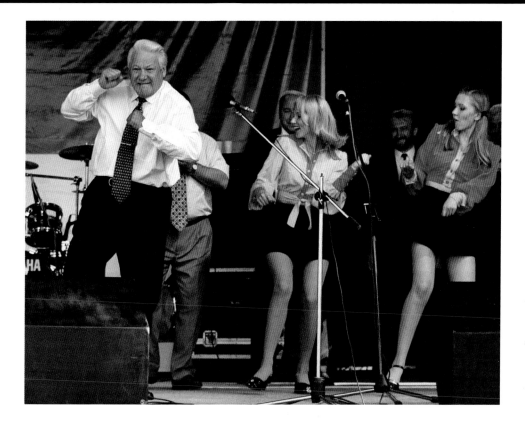

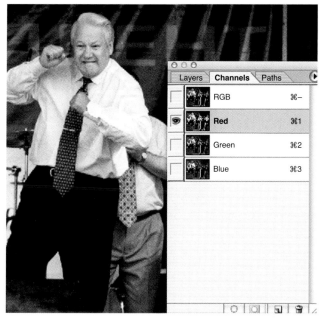

Original image (above)
The original RGB TIFF file.

Channels screengrab (left)
Here we see the three separate channels appear together with the image. The red channel has been selected. Splitting the image into three separate channels can be compared to shooting black and white through separate RGB filters. Each filter will create a different effect.

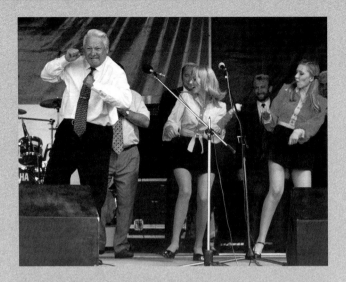

Original image converted through Greyscale mode

This file was converted to monochrome using the simple method of stripping out the colour via Image > Mode > Greyscale. As the colour has been discarded, the file size has reduced.

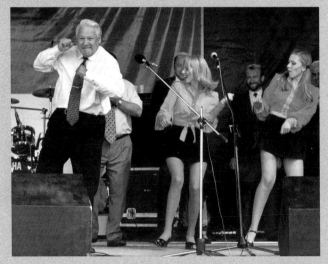

Original image converted using the Desaturate tool

This example was converted to greyscale via the path Desaturate > Image > Adjustments > Desaturate. The file has retained all its original information and can be converted back into RGB.

Original image converted using the Hue/Saturation tool

This image was converted via Image > Adjustments > Hue/Saturation. This method provides more control and with the saturation set at -100, the image is monochrome; no information is lost and the image can be reverted back to RGB.

Original image with tone added via the Hue/Saturation tool

By checking the Colourize box and manually adjusting the sliders, the Hue/Saturation tool can also be used to add extra tone to an image – in this case similar to a thiocarbamide effect.

Thai lily, original image (above)

This image was shot in Bangkok, Thailand. The negative was scanned and imported into Photoshop.

Photographer: Steve Macleod.

Technical summary: The image was converted to greyscale via the Image > Adjustments > Channel Mixer menus. The grey channel was pulled up by checking the Monochrome box. RGB values of 70 per cent red, 20 per cent green and 10 per cent blue were entered separately.

Basic image balance using Levels and Curves

When it comes to basic digital file balance we are typically trying to get to a basic starting point in exposure and contrast, in much the same way as a traditional darkroom worker would. The two digital tools used for this are Levels and Curves.

When working on a new file, particularly one that has been converted to monochrome, some adjustments are usually made to make the image print-ready. It is better to use a file that retains RGB format rather than simple greyscale because more control can be taken in manipulating the image using the adjustment tools.

Most people often use the Brightness/Contrast option tool when making adjustments to the brightness/exposure and contrast in an image. However, this simple control provides a very limited degree of control and improvement. The Levels option offers greater degrees of control. It can be found by selecting Image > Adjustments > Levels. A histogram indicates the the distribution of tonal levels across an image.

A good histogram will feature data at all points; gaps in the histogram indicate that there is no tonal data in that range. Often, it will be the case that there is no data at the start and end of the histogram, which corresponds to no true blacks or whites in the image. Deficiencies such as this can be corrected either by clicking on the Auto box or by moving the sliders (the small triangles beneath the ends of the histogram) inwards until they touch the start of the histogram data.

To make corrections, select the Threshold Display mode. Hold down the Alt key whilst sliding the left-hand or shadow indicator. This has the effect of posterising the image, progressively revealing the darkest areas as the slider is dragged inward. If the slide goes too far the extreme shadow detail may be clipped and lost. The same technique can be used to determine the highlight adjustment. This time hold down the Alt key and drag the right-hand arrow inwards. For example, the extreme highlight in the image on page 85 is on Yeltsin's left arm; this was burning out so a new highlight level was set at 253 (from 255). Again, do not go too far inwards as the highlights will become clipped. The middle arrow determines the overall lightness of the image and is called the 'gamma slider'. By dragging it to the left the image will appear brighter and to the right, darker.

The Curves method of adjustment can at first be quite difficult to master, but once a little experience is gained it will offer even more control. The shadow and highlight parameters can be set in the same way as the Levels tool and, in addition to this, the individual contrast can be altered in the three separate channels – if the image has retained the RGB format. To access the Curves dialogue select Image > Adjustments > Curves. It is adjacent to the Levels command.

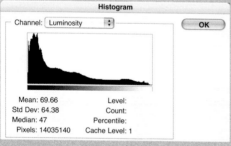

Histogram screen grab

The original Boris Yeltsin image and its histogram show that the image is heavily biased towards the darker regions and lacks tonal range. The image was converted to monochrome via the Hue/Saturation option with the saturation set to –100. The Levels histogram shows the various levels of tonal concentration.

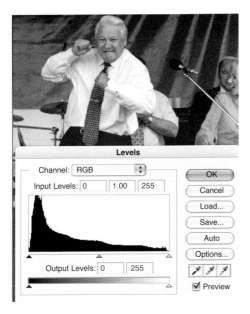

Levels menu adjustments (left)

The Levels menu shows the bias of the file towards the shadow regions. The sliders below the graph can be adjusted to alter the feel of the image.

Final image (below)

The overall effect is a balanced image with a full tonal range, and is predominantly lighter than the original. The split tone warms up the file, creating a timeless feel to the image. Recreating darkroom toning effects can be easily achieved using the methods discussed.

Prague trees (right and facing page)

This image was scanned for maximum detail; it is open and has a wide tonal range – the preferred starting point of most digital operators. The following images show adjustments applied to the original image using the Curves tool.

Photographer: Steve Macleod.

Technical summary: Rolleiflex 2.8 GX, Kodak TRI-X 400 rated at 320, processed normal. The negative was hi-res drum-scanned and was produced as a test image for the digital FB paper used.

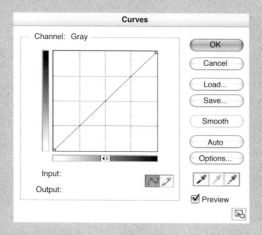

Original image

The Curves dialogue box is characterised by a diagonal line graph representing the direct relationship between the input and output levels. The graph also represents the tonal range of the image, from 0 at the bottom left (representing shadows), and 255 at the top right (representing highlights). The horizontal axis controls the input values and the vertical axis the output values.

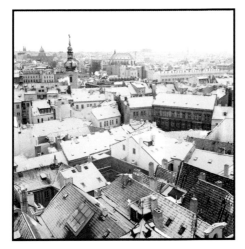

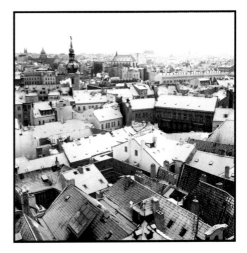

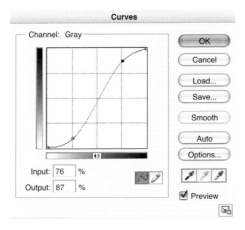

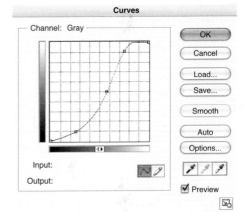

Image 2

Using the Curves dialogue box, more contrast was added to the image by clicking about three quarters of the way up the linear line, thus creating an 'S' curve similar to that of analogue film. This introduced contrast to the image, resulting in a much cleaner looking image than the original file.

Image 3

On the horizontal output bar of the Curves graph there are two small arrows. By clicking on these the input and output ranges will become reversed, and by also holding down Alt and clicking anywhere on the grid area, the grid unit measure will toggle between 25 and 10 per cent units, allowing for more accurate control.

Dodge and burn

Images can be dodged and burned in Photoshop in the same way as a conventional print, the only difference being the effects can be seen immediately in the digital method. Both the Dodge and Burn applications are in the Tools section of Photoshop. Unlike the analogue methods of burning and dodging, it is possible to select a brush tool with which to 'brush on' the effects. These brushes can be large or small, soft-edged or hard-edged. Once a brush has been chosen, the parts of the image to be touched-up need to be selected as well. Image highlights, mid-tones or shadows can all benefit from treatment. If you select to burn a shadow area, any adjacent mid-tones or highlights will be unaffected.

As always, the aim is to improve the image without the manipulations becoming obvious. Dodge and burn tools are really intended to be used for small-scale corrections. Major corrections and manipulations to images can be made using the Levels and/or Curves controls and then Dodge and Burn tools used to refine the adjustments. It is worth noting that in the more recent versions of Photoshop, Adobe have included a feature called Shadow/Highlights.

This feature is a good – if slightly arbitrary – command that can be used to reduce the brightness of highlights and the depth of shadows. It should be used with mild settings and in conjunction with other tools such as Dodge and Burn for applying fine, local control. If unsure where to begin, practice with brush and opacity options. A better and more controllable method is to use the Levels and Curves options, which provide a more subtle approach to burning and dodging – the effect has a more conventional darkroom feel. Applying feathered selections via the Levels and Curves options does this even more effectively.

'There is only you and your camera. The limitations in your photography are in yourself, for what we see is what we are.'
Ernst Haas

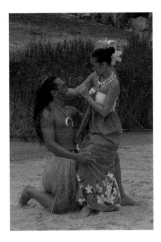 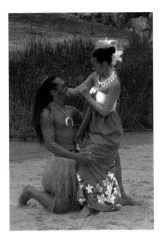 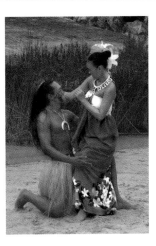

Original image

These Mauri dancers put on a colourful display – a gift for colour photography. However, the results straight from the camera are somewhat lacklustre for black and white. This can be improved by using the Dodge and Burn tools.

Dodge tool

To begin with, the Dodge tool is used to lighten the brighter parts of the image. For example, the lily in the female dancer's hair and the flowers on her dress can be brightened. This immediately gives the image a 'lift'. The same was applied to the jewellery on both dancers.

Burn tool

Both the Dodge and the Burn tools were used to lighten and darken selected parts of the subjects' skins to enhance muscle definition and details in the face and neck. The Burn tool was also used to enhance the definition in the girl's dress; the dodge tool lightened the brighter parts of the raffia skirt.

Mauri dancers (above)

The above are images of Mauri dancers originally shot in colour. A black-and-white version of the original image was improved by applying the Dodge and Burn tools.

Photographer: Peter Cope.

Technical summary: Not available.

In the last two chapters we explored many of the stages that go towards producing photographic prints. Now we need to look more closely at the mechanics. A sound understanding of the processes – both basic and advanced – used in the darkroom also relies on knowledge of the underlying technology. We will look at paper construction, the ranges of paper currently on the market, and how we can successfully use various paper types in the darkroom.

There are additional techniques that can be employed on top of making straight prints. These techniques help to enhance the longevity of prints and extend the limits and capabilities of certain paper stocks. This chapter will also address key issues involved in producing high-quality prints across a much wider range of situations, from a wider array of original negatives.

'The marvels of daily life are exciting; no movie director can arrange the unexpected that you find in the street.'
Robert Doisneau

Tulip (facing page)
This is an example of a post-flashed print, which maintains subtle highlight details.
Photographer: Bruce Rae.
Technical summary: Agfa Multicontrast paper, developed in Agfa Neutol WA developer.

Paper

The paper on which we print photographs is much more than a mere substrate. Its design and characteristics can, almost as much as photographic vision, impart a quality and style to images. Attend a photographic exhibition with some photographers or printing experts and you will discover that they can often identify a print, not only by its photographic style, but also by the paper it is printed on. An understanding of the construction of photographic paper and a knowledge of the attributes of some popular paper stocks gives photographers a head start in creating the best images.

Paper construction

Photographic paper is constructed in a similar fashion to black-and-white film. Silver halide grains are suspended in gelatin and applied to a paper or card substrate. The larger the grain on the image, the blacker that portion will become. Close inspection of the development process will reveal that when a developer first reacts with the grains in the paper, they begin to turn a pale sepia colour. They then turn black, when development is complete.
If a print has a distinct brown colouration, it is safe to assume the paper did not have enough time in the developer.

Photographic papers also have an emulsion surface. There are three types of light-sensitive emulsion used for conventional papers: bromide, chloride and chlorobromide. Each of these has slightly different characteristics and will determine the papers' tonal range and qualities. The main difference between these formulations is the proportion of silver bromide and silver chloride in the emulsion. Most combine elements of both and in general, those with a higher percentage of chloride tend to be slower in speed and deliver images of warmer olive to brown-black tones. These papers are also more responsive to toning chemicals: toners (which produce prints that are tinted) work well with these papers. Papers with a higher percentage of bromide tend to be more light-sensitive, producing more neutral and cooler blacks.

Author's tip

As with much of darkroom practice, choosing which paper to use is a combination of subjectivity and experience. The sound use of appropriate paper type, exposure and development can do much to enhance an image; misuse and negligence can detract from the potential quality.

There are no rules governing paper choice but it is generally regarded that colder and neutral tones can put some subjective distance between the viewer and image; a warmer toned print can appear more engaging, drawing the viewer in.

Experiment with different brands and samples so that comparisons could be made and applied to your particular style of image-making. Most photographers end up with a small selection of papers that they use because it suits their style of photography and printing.

The Cuilins, Isle of Skye (above)

This photograph was processed in lith developer to convey warmth and contrast. It was also printed on a very warm and textured 'watercolour texture' surface paper.

Photographer: Steve Macleod.

Technical summary: Hasselblad CM standard 80mm lens, Ilford HP5 rated normal, push-processed in Ilford Perceptol developer 1:3, Kentmere Art Classic paper and lith developer.

Paper types

Apart from the different chemistry that applies to the emulsion, another factor that distinguishes different paper types is the base that the emulsion is laid on. As mentioned previously, the two key types are resin-coated (RC) and fibre-based (FB). The main difference between them is that RC papers have an impervious barrier applied to them, which prevents the developing chemistry from penetrating the substrate or support. The purpose of this is to limit chemical carry-over and contamination, therefore decreasing wash times.

Resin-coated papers have the texture and feel of a plastic film. On the other hand, fibre-based papers have no such coating, which allows the paper to be penetrated more easily by chemicals, demanding a more thorough washing. Which is best? Professional users tend to use FB papers for important or archival prints as it offers a wider range of paper base-colour tints and image tone. FB papers are more receptive to print toning and are longer lasting; spots and scratches are also easier to remove on FB papers. Properly stored FB prints produced under optimum conditions can last over 100 years, whereas the equivalent life of an RC print may be as low as 15 years.

Paper surfaces

Another criterion used to classify photographic paper is surface finish. Conventionally, a high-gloss finish is preferred. This is the best paper for showcasing fine detail in prints. It is also good for displaying high-contrast ranges and producing prints that exhibit 'punch'.

Semi-gloss and pearl finishes offer results that are almost as good, but the softer surface is not so prone to reflections.

Matt-finish papers give the lowest resolution of all the 'flat' surfaces. It is also possible to find specialised printing surfaces that emulate different surfaces, such as canvas, watercolour paper and even handmade papers.

Cobbles, Tbilisi, Georgia (facing page)
This photograph was shot following heavy rainfall and searing winter sunshine. It was printed on Fotospeed Legacy DW, a neutral/warm paper that reacts well to toning.

Photographer: Steve Macleod.

Technical summary: Ilford HP5 35mm rated normal and processed at +1/2, printed on Fotospeed Legacy DW.

Paper brands and quality
The creators of photographic paper tend to produce families of papers with distinct characteristics. The chances are, if you like one paper from a particular manufacturer, you'll also like others from their portfolio. Despite all the effort being devoted to the design and production of digital photographic papers, there are still several traditional paper manufacturers supplying a wide range of papers, from cold, neutral to warm tone variations. The following are some of the main ones:

Bergger
Available from Linhof & Studio and Silverprint, these are considered the premier papers and are appreciated by discerning fine art printers. The Prestige Fine Art paper is a heavyweight paper with wide tonal range. Variations in contrast are unusually achieved and altered by varying exposure and development. They also produce an alternative paper called Bromoil, which is a bromide-rich formulation. <www.linhofstudio.com>

Fotospeed
This company produces a modest range of papers, including some fine papers such as the Legacy, a double-weight, neutral- to warm-tone paper. This works well with toning chemicals. Fotospeed also produce Lith printing paper, a specialist paper for very high-contrast effect. Also included are the resin-coated VC in Gloss and Oyster (mid-sheen) finish that works well with toners. Also available is the Fotolinen, which is an emulsion applied to a cotton canvas. <www.fotospeed.com>

Harman Technology
Inheriting the Ilford Photo names and brands, this company produces some industry-standard products including a full range of black-and-white papers and chemistry. New products have shown this manufacturer to be an innovator and have secured its position as the industry number one. As well as the standard multigrade FB and RC papers there is an FB warm tone (available in gloss and semi-matt finishes) that has a warmer and creamier paper base than the usual standard. <www.ilfordphoto.com>

Kentmere
This manufacturer provides a range of good quality papers aimed at the fine art printer, from the Kenthene and Bromide graded papers through to the Fineprint VC and Kentona ranges. <www.kentmere.co.uk>

Maco
A German-based manufacturer with two particular papers: the EXPO Ag (a silver, metallic RC paper) and the Structuralux, which has the emulsion applied to a cotton-linen base. Also available is the RF/RN fibre-based paper, which is a chloro-bromide graded paper. <www.silverprint.co.uk>

Sid & Marty's, Bath (above)

Shot in early morning sunshine, this print shows how paper choice can influence and maximise the creative potential of an image.

Photographer: Steve Macleod.

Technical summary: MPP Mk VII 5'' x 4'', double toned in thiocarbamide and selenium, printed on Ilford Warmtone Glossy paper.

Paper processing and handling

When it comes to processing paper, it helps to follow the guidelines below:

- Be mindful that many of the chemicals you will be using are highly corrosive and potentially toxic; sensible precautions need to be taken and – where appropriate – health and safety guidelines, as advised by the manufacturer, adhered to.

- Never place the paper face down in the developing tray or force the paper down on to the liquid – this can result in uneven development. Air bubbles (and potential scratches from the tray bottom) will affect the quality of your image. By sliding the print in face up you have a better chance of protecting the print and creating even development; you can also watch as the image develops and comes to life.

- Always slide the paper in from one end and remove from the opposite end; larger prints should be removed by a corner, allowed to drain and then transferred across to the next tray.

- Place the trays close to each other, but not too close as this results in cross-contamination.

- Keep the wet and dry areas as far away from each other as possible; always use fresh chemicals where required, because some contamination is inevitable as the print passes from to tray to tray in the printing process.

- There should never be any reversed workflow contamination: the fixer must not pass back to stop bath, nor stop bath to developer. If this happens discard the chemicals.

- Avoid splashing chemicals from tray to tray; only fill the trays halfway and use gentle agitation to process paper.

Paper developers are an alkali-based mix of chemicals. They are not designed to solely develop film grains; speed of development, contrast and tonal warmth are also taken into consideration. The important elements of any developer are the active agents, such as glycin, chlorohydroquinone, anti-foggant benzotriazole – which provides cool tones – and the bromide restrainer – for warmer tones. Many different types of developer are readily available off the shelf, such as Kodak Dektol (great for cold tones), Ilford PQ, which is excellent when neutral tones are called for (as it has a higher concentration of sodium sulfite), and Ilford Warmtone, which boasts a higher percentage of bromide restrainer.

The time taken to develop a sheet of film will vary according to temperature, exposure and concentration, as well as the specific developer chemistry. It is generally true to say that the longer the development time, the greater the tonal range. It is crucial to follow the manufacturers' guidelines for best results.

Shevshenko (above)

This strong portrait was printed very dark and heavy in order to give an aggressive feel to the image. Although printed at high contrast, detail is still retained in the highlights to provide overall balance.

Photographer: Hamish Brown.

Technical summary: Mamiya RZ67, Kodak TRI-X 400 film rated normal, printed on Ilford Warmtone Glossy.

Developing chemistry

Developers are normally diluted at a working temperature of 20 degrees Celsius. By varying the dilution and temperature, interesting tonal and contrast changes in the print can be achieved, but results can be unpredictable! It is good practice to keep note of any experimentation as it can be very disheartening to produce a fantastic print only to find that it can't be reproduced.

As more and more prints are produced, the developer will become exhausted. This will be noticeable as the time it takes to produce a good quality print will increase substantially, but print quality will not live up to expectations. To monitor these elements, use a process called **factorial development**: begin with fresh chemistry and note down how long it takes for an image to appear. The full development then proceeds as a multiple of this time.

For example, if it takes 15 seconds for the image to first appear and full development is reached in 90 seconds, the factor is 6 (15 x 6 = 90). When using depleted developer and the image does not begin to appear until after 25 seconds of exposure to the developer, you will need to give the print 150 seconds for total development. Once the time for an image increases inordinately, the developer is exhausted and must be discarded then replaced.

Stop bath

The **stop bath** has two purposes. It extends the life of the fixer and it stops the action of the developer. The stop bath is made up of a dilute solution of acetic acid, which neutralises the alkali developer. Unlike the developer and fixer, where quality is absolutely paramount, the stop bath is a simple chemical that can be sourced cheaply – it can even be found in some chemists' stores. It is normally available in a 60% solution that will need to be diluted one part stop bath to thirty of water.

Fixer

The purpose of the **fixer** bath is to remove any undeveloped silver that is not used in making the visible image. As residual silver is invisible to the naked eye it is very important to always use fresh chemicals and to follow the manufacturers' guidelines. Exhausted fixer may damage a print and concentrated fixer can have a bleaching action. A fixer solution that is too diluted will result in insufficient fixing and clearing of base dyes.

Dilute fixer to a working solution 1:4 with water and follow the timing guidelines carefully. The most obvious signs of a badly fixed print are yellow casts or brown stains to the paper. Prints produced for archival purposes need to be fixed correctly and accurately in order to last a considerable amount of time.

It is worth checking the efficacy of the fixing process by using commercially available indicator kits. These will verify whether the prints are stable enough for archiving. Another method is to use undiluted selenium toner (Kodak and Ilford currently manufacture this). If there is any silver left in the print it will show up as a brown stain. Should any of these tests reveal a problem the only remedy is to fix and rewash the print and to try the test again; otherwise the print will surely deteriorate over time.

Washing

When successfully fixed, prints must still be washed to ensure that all residual chemicals are completely removed. Prints can be washed quite sufficiently by using tap water. However, even better results can be achieved (and time can be saved) by using a washing additive such as Ilford Washaid – this eases the removal of any residual chemical.

Many photographers still drop their prints into a sink with water trickling over it. This method is effective to a point but ultimately, it is neither thorough nor rigorous enough. Consider using a cascade wash or an upright archival tank – an ingenious space-saving device, which ensures an even flow of water on to the print surface. This tank is divided up into sections and each print is suspended upright in the wash with a clear flow of water rising up through the print, and out over the run-off at the top. Wash prints for as long as is practical; however, also bear in mind that warmer chloro-bromide papers result in a visible warming of the image tone when washed for extended periods.

Drying

Once prints have been washed, they should be carefully wiped (using a specially designed squeegee) on both sides to remove any excess water; take particular care not to scratch the emulsion side of the paper. There are many methods for drying prints – RC papers such as the Ilford 2150 are often dried through heated roller driers. FB papers are often air dried flat between sheets of blotting paper, preferably on a mesh screen to aid air circulation, or hung up and clipped back to back to prevent curling.

In commercial labs a heated belt drier is used to express water out of the paper, thereby speeding up the process. Handle paper with care when wet – this is when paper is at its weakest. Papers dry at different rates and with varying flatness. Paper curl is common to all FB papers, and when fully dry can be flattened under heavy sheets of glass on a hard surface. Some darkrooms may boast a flatbed heat press, which combines a heated element with a heavy metal plate to compress the paper.

factorial development process used to monitor the elements and chemicals used in the developing process; i.e. begin with fresh chemistry and note down how long it takes for an image to appear; full development proceeds as a multiple of this time
stop bath an acidic solution that neutralises alkaline developer and stops the developing process
fixer removes any undeveloped silver during the development process, which is not used in making the visible image

Toning prints

Toning is an additional process applied to a print resulting in a change to the colour. There are two main reasons for choosing to tone prints. First is for archival stability – toner converts the silver in the image to something that is more stable. The toning process might introduce dyes that are themselves more stable than silver and will thus result in a more long-lived print. The second is for reasons of creativity. You might want to change the colour of a print to alter its look and feel and give it a different 'atmosphere'. Do not tone a print to compensate for shoddy or unsatisfactory printing – a poor source print will not be enhanced in any way by toning.

Indirect and conversion toners

Indirect toners (also known as conversion toners) are so called because they use a bleach bath to bleach the image prior to applying the toning medium. After bleaching the image, the original full tonal range reappears albeit with the tone colour. In the past strong chemicals such as sulphide were used in toners to provide a true, deep-brown tone. Nowadays the less offensive and odourless thiocarbamide toner is used. This is a combination of two components and depending on the balance of each, this toner can provide a range of tones from yellow-brown to more ochre warm-brown. It is sometimes described as 'variable sepia'. Using this toner requires two baths.

First, the print is bleached using a bath made up of potassium ferricyanide and potassium bromide. This solution does not last well in the air so is generally kept as a concentrate and made up as a working solution prior to toning. The action of the bleach first becomes apparent in the highlight regions, but progresses throughout the print tone.

Halting this action in a clearing bath of water controls the areas on the image affected by the second bath toner. If the process is halted early on, only the highlights will be affected, which will create a split-tone effect once toned. If the bleach reacts with all of the image then there will be a more even tone throughout the image.

Remember that toning can also affect the contrast of the final print. This is most noticeable when using bleach baths as the highlights can be lost due to the action of the bleach. Shadow detail can also be lost when producing warmer-brown tones: they can become dull and muddy looking. It is possible to compensate for this in the initial printing stage. Make the highlights a bit darker and shadow areas more open; try printing with slightly less contrast and overall exposure density. Once the print has been bleached it must be cleared in a bath of slow running water, ready for second bath toning. This should be done for a minimum of five minutes. The print is then ready to be toned.

The key (above)

This image was shot on Polaroid Type 55, printed with the rebate intact and exposed through a sheet of muslin whilst being printed. The print was then bleached and toned using a warm thiocarbamide toner before being toned in cold Kodak selenium.

Photographer: Fredrik Clement.

Technical summary: Polaroid Type 55, bleached and toned using warm thiocarbamide and then toned in cold Kodak Selenium Toner.

Toner solution is a combination of sodium hydroxide and thiocarbamide. This can be bought commercially or can be made up from your own stock solutions. Mix 100g of each in a litre of water and then mix these together as shown below to make your working solution prior to toning. It is the relative balance of each toner that will provide varying colour shift.

Sol.A 100g of sodium hydroxide in one litre of water
Sol.B 100g of thiocarbamide in one litre of water

Sol.A	Sol.B	Colour
80ml	20ml	purple-brown
70ml	30ml	cold-brown
30ml	70ml	warm-brown
20ml	80ml	yellow-brown

As the print is placed in the bath image tone will gradually appear. The speed of the toning process will depend upon the amount of sodium hydroxide in the mix. The more sodium, the quicker the image will come up; the more thiocarbamide, the slower the process. Sometimes prints produced in this way have a scummy white residue on the surface. This can be cleared by immersing the print in a five per cent solution of acetic acid (stop bath) and then re-washed.

There are some types of direct sulphide toners that convert the silver into a silver sulphide. Agfa Viradon and Kodak Brown toner were both commonly used, but as with most requests for print toning this is slowly dying out. If you do try using these toners be sure to follow the manufacturers' safety guidelines as they will give off a hydrogen sulphide gas.

'Photography takes an instant out of time, altering life by holding it still.'
Dorothea Lange

Spotlit (above)

This is an example of a cold thiocarbamide print. It was partially bleached so that when toned some of the original black tones were retained.

Photographer: Mark Guthrie.

Technical summary: Thiocarbamide-toned print, Kodak Ektalure paper, Agfa Neutol WA developer.

Doors (facing page)

This is an example of a warm thiocarbamide print, initially fully bleached so that once toned all of the image would be affected by the toner. The photographer wanted this image to be dark and moody, giving an emphasis to the symmetry.

Photographer: Samman.

Technical summary:

35mm negative, HP5+ film processed at +1, printed on Kentmere Fineprint.

Gold chloride and selenium toners

Gold chloride and selenium toners are often described as direct toners because they act directly on the silver in an image and convert the grains to gold chloride and selenium selenide, respectively. Both these toning processes were historically used for their archival properties. Although both toners tended to produce very attractive blue-black or slate-coloured tones, photographers would remove the print from the toning solution at the precise moment the silver was converted, and before the tone would have a chance to take effect.

Gold toner is normally supplied commercially and comes in undiluted solution ready for use. This is a slow-acting toner and can take up to five minutes before any shift in colour starts. Selenium toner also comes in liquid form but is diluted before use.

Different paper types will provide varying tones so it is worth experimenting with different dilution and paper combinations. A general rule to bear in mind is that higher concentrations provide warmer and more purple tones, and as the solution is diluted the colour shifts to colder, red tones. Use dilution ratios of 1:8 or 1:20, depending on the desired effect.

Unlike other processing chemicals, never discard selenium toner. It can be kept and topped up with fresh solution. Some photographers value the mature toner's results because it produces better and better results even though the working dilution becomes inaccurate to time.

Sandside, Caithness (facing page)

This image was Forte Polywarmtone toned in a warm Kodak Selenium Toner for five minutes, providing a deep, warm, purple tone.

Photographer: Steve Macleod.

Technical summary: Hasselblad CM, Ilford HP5, Forte Polywarmtone, Kodak Selenium Toner.

Dye toners

Dye toners produce numerous coloured effects. However, many will shorten image life and stability compared with metal-based or other non-dye toned images. There are two types of dye toner: mordant and straight.

Mordant toners use a bleach–dye combination, where the bleach bath converts the silver to silver iodide (or sometimes to silver ferricyanide). This makes the silver grains receptive to specialised carbon-based organic dyes. The amount of dye that appears in the image bears a direct relationship to the density of the silver in the bleached image.

A common mordant blue toner consists of the following two bath solutions:

Bleach bath:

30g of potassium ferricyanide mixed into 10 per cent, 100ml solution of ammonia. This is diluted to 1 litre working solution.

Once the bleach bath is completed, the print is thoroughly cleared and toned in the following:

Tinting bath:

20g of ferrous sulphate mixed into 10 per cent, 100ml solution of hydrochloric acid and then diluted to 1 litre working solution.

Straight dye toners affect all of the image as none of the silver is converted. Most common are blue and green toners. These are commonly a mixture of a two-part solution that can be made up and stored in opaque bottles. The two solutions are as follows:

Part A

A 10 per cent solution of potassium ferricyanide in 20ml of water, mixed with a 10 per cent solution of sulphuric acid in 35ml of water. This is then made up to 1 litre working strength.

Part B

A 10 per cent solution of ferric ammonium citrate diluted in 20ml of water is mixed with a 10 per cent solution of sulphuric acid in 35ml of water. This is then made up to 1 litre working strength.

Equal parts of A and B need to be mixed prior to use and discarded as the toner exhausts. When using these types of toner, indeed any toner, always ensure that the print is submerged evenly into the toning bath and agitated during the toning process.

My hands (above)

This image was shot from below through a water jacket. It was used to promote Primary printing services.

Photographer: Ray Massey.

Technical summary: Ilford Warmtone Semi-Matt, toned in Rayco blue toner.

Split and multiple-toning processes

Split or multiple-toning processes use two (or more) toning processes to tone different parts of a print. The results are known as duochromes (if two tones are involved) and tritones (three tones). As experience with toners grows, it will become easier to recognise that each different chemical and combination will work in a different way, and that they affect either all of the print or just certain parts it.

It is important to remember that conversion toners such as selenium will prevent the effective use of bleach or indirect toners. Dye toners such as blue and green must follow any indirect toner such as thiocarbamide as the thiocarbamide will clear out any dye from the print. Common combinations such as gold chloride over cold/yellow thiocarbamide will produce rich pink/red/peach tones, whereas selenium over thiocarbamide can reproduce rich purples and brown splits.

Here are some examples of the effects that can be achieved using multiple toning:

First Toner	Second Toner	Net result
Sepia	Blue	Sepia-toned highlights, blue shadows, brown/green mid-tones
Sepia	Selenium	Brown highlights, purple shadows
Blue dye toner	Selenium	Brown/beige highlights, blue shadows

Author's tip

To get the best results from toning projects, the following advice is suggested by Ilford and other toner manufacturers:

- For best effects reduce the toning time for the first toner by about one quarter.
- Wash the print thoroughly prior to using the second toner to avoid any contamination, which could cause discolouration.
- Monitor the print in the second toner and remove the print when the desired effect is achieved.
- Pay particular attention to the shadows in the second toner bath – the second toner will tone the shadow areas.
- Adjust the relative timings of the two toners to vary the balance between highlight and shadow tones.

Portrait (facing page)

This image was shot on a Polaroid Type 55. The print was bleached and toned to create the deep, warm texture.

Photographer: Andrew Lamb.

Technical summary: Polaroid Type 55, bleached and toned in warm thiocarbamide and then selenium at 30°C, printed on Kodak Ektalure paper with Kodak Selenium Toner.

Advanced techniques

The opportunities offered by digital imaging manipulation have provided photographers with a simple means of producing impressive effects. Many of the techniques (such as dodging and burning) owe their origins to conventional darkroom techniques. Others are more abstract. However, the high profile of digital photography has tended to eclipse the possibilities still afforded by the traditional darkroom. The skilled darkroom worker can produce some intriguing effects and powerful imagery that rivals the best from the digital darkroom. Here we will take a look at just two: **split-grade printing** and **pre-** and **post-flashing**.

Split-grade printing

Split-grade printing is a process that, as the name suggests, involves the use of more than one contrast grade in a single print. The process takes advantage of variable contrast paper and its multi-layer emulsion, which is sensitive to both blue and blue/green light. The simplest method of split-grade printing is to divide the total exposure time into two parts.

Set the filtration for the paper for maximum contrast (Grade 5) and expose for the first half of the time. This will provide high contrast for the shadow areas. As described earlier, it is necessary to allow extra exposure time when using Grade 5 in order to account for the heavy filtration.

At the end of this first exposure reconfigure the filtration for Grade 0 and expose for a second time, exposing this time for the highlights. The net result is an image with an average Grade 2 or 3 contrast, but with extra detailing in the extreme tones.

A more flexible method preferred by some photographers is to print the basic or primary exposure at the preferred grade and then to apply a second exposure to burn in parts of the scene at a second grade. This is preferred by many photographers because it allows them to work at the grade they consider best for the overall image. It also allows them to use the modified grades selectively in order to enhance those parts of the image that would not otherwise be adequately reproduced by the basic filtration.

split-grade printing a process that involves the use of more than one contrast grade in a single print
pre- and **post-flashing** a technique which involves giving photographic paper a brief exposure to light prior to development in order to overcome the inertia point of the paper

Women looking through window, Kashmir (below and following pages)
The following three images illustrate the various effects that can be achieved using advanced techniques in printmaking.

Photographer: Gary Knight.

Technical summary: F11, Grade 3, for 25 seconds.

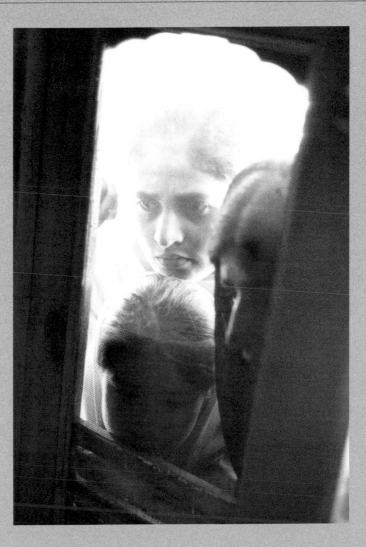

Basic print
This image is made up of extreme highlight and shadow details. The key was to maintain elements of shadow to provide depth, while also bringing out subtle detail from the highlights, without destroying the soft backlighting. This basic print allowed for an assessment to be made between the light and dark areas.

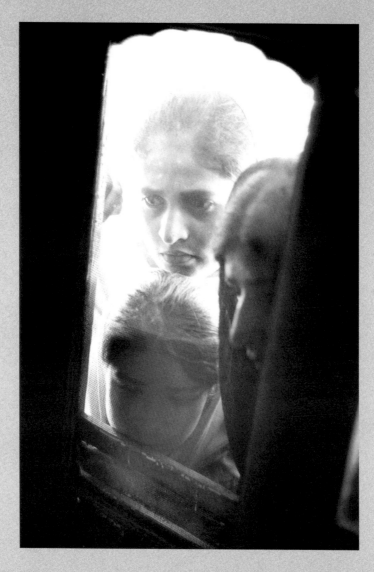

Print 2

The filtration was increased and the print exposed again. The little girl's face was dodged for ten seconds, and the bottom of the wooden frame for five seconds. The window on the right-hand side was burned in for 15 seconds, and the top of the woman's head for ten seconds. The result was quite pleasing, but still lacked something.

Print 3

The same steps were taken as in the previous print, but the girl was only dodged for five seconds. A switch to Grade 2 was made in order to burn the girl's face. This softened the grainy quality of the print. The final print retains the subtlety in the shadows, and the split-grade printing successfully brings in the tone without sacrificing the backlit glow of the image.

Fashion shoot for The Face (below and facing page)

The following two images further illustrate the effects of advanced printing techniques by comparing and contrasting the basic print and the second print.

Photographer: Corinne Day.

Technical summary: Ilford Warmtone Glossy, f11 Grade 3 for 40 seconds, developed in Agfa WA diluted 1:9 at 20°C for two minutes.

Basic print

The original image needed to be cropped and looked too light and flat, even though the highlights needed some burning in.

Print 2

The image was re-cropped so the model appears closer and uncomfortably off centre; the contrast was increased to Grade 3 1/2. An exposure of 60 seconds was made to compensate for the increase in the enlarger head height, and to darken the overall print. The left-hand side of the girl's face and torso were held back during the exposure for -10 seconds. Switching to Grade 2, the right-hand side of the girl's face was darkened for +10 seconds in order to achieve some light skin tone. Finally, the right-hand side of the image background was burned for +10 seconds to balance the tone from right to left. The result is quite a subtle shift in the values without making the print look overworked.

Pre- and post-flashing

There are times when no amount of over-exposing or burning-in could overcome grainy results. Overexposed grains tend to clump together and make parts of an image look particularly crude and different in texture compared to rest of the print. This problem could be resolved by using a technique known as pre-flashing; this also adds general tones to problem areas. Pre-flashing involves giving the photographic paper a weak and uniform exposure to light prior to printing.

All printing papers (like film) have a minimum exposure threshold where they are receptive to light. This is called the inertia point. The pre-flashing process effectively gives the paper a 'kick-start' to overcome this inertia. It makes little difference as to whether this flash of light is applied prior to exposing the paper to the negative or afterwards – the result is the same. Some photograhic printers prefer to flash the paper prior to printing and some will pre-flash whole boxes of paper at a time. Doing this on an almost industrial scale is not normally recommended as contemporary papers are prone to interpret the pre-flash as a light fog if the paper is not used in a short period of time.

Each type of paper has a different inertia point and the amount of light that falls on the baseboard of an enlarger can vary widely. This depends upon the output of the light source, the distance of the baseboard from the head, the lens, and sometimes even the age of the light source. Light sources can change their characteristics with time.

Pre- and post-flashing are simple and effective processes. Once work on the print has been completed, remove the negative from the carrier. Leave the paper in the easel and replace the now-empty negative carrier. Expose the paper sheet for the pre-determined minimal exposure. In order to determine the amount of exposure that is needed, conduct a base fog test. This test exposes the photographic paper to increasingly longer amounts of light until the light starts to fog the paper. When this point is reached the light has done all it can to overcome the inertia point of the paper and is now merely fogging it.

Shoot a test sheet as earlier to calculate the optimum exposure. This time, however, do the test with no negative in the enlarger. With the lens stopped down to a normal working f-stop (say f11) and using an opaque sheet of card to cover the paper, make exposures in increments of half a second across the paper. When the paper is processed a print with a stepped greyscale will appear. Make a note of the exposure time that corresponds to the strip just prior to the first discernable grey tone. This grey tone represents the base fog point, where the light exposure is now fogging the paper. Any pre-flashing (or post-flashing) exposure should be less than this for the base fog point.

It is important to be aware that print contrast can be compromised by flashing paper. There is also the risk of slightly overexposing the whole image. This can be compensated for by increasing the contrast grade of the print and cutting the initial exposure during the working of the print. Also bear in mind that if you intend to tone your print afterwards you should increase the pre-flash to compensate for any contrast changes that will result from print bleaching.

Successful proponents of the pre-flash technique will also selectively flash discrete areas of a print to alter the effects of subtle shadow detail. This is done by recreating shapes and masks for the image, which will shield the effect of any flashing in exactly the same manner as when dodging and burning. Like many creative techniques in the darkroom there are no precise or definite rules for either split-grade printing or pre-flashing. Trial and error, gained skills and experience count for a lot. It is also true to say that much of the resulting image improvements can be subjective and are open to interpretation.

Legs (left and following pages)
The following images show the effects of dodging and burning, combined with post-flashing techniques.
Photographer: Jade Smith.
Technical summary: F16, Grade 3 for 15 seconds.

Legs: basic print
This basic print shows good tonal range but is somewhat flat. The photographer wanted to achieve a simple but graphic look.

Print 2

This image was cropped quite tightly and reprinted at Grade 4 for 15 seconds, holding back the shadow on the knee and thigh areas. The shoes were burned in for +5 seconds to make them more striking. The background was brought down in tone by +5 seconds to balance the image.

Print 3

This was printed as the previous example, but post-flashed. The printing sequence was repeated and the negative removed from the carrier and flashed for 3 seconds at f16, Grade 4.

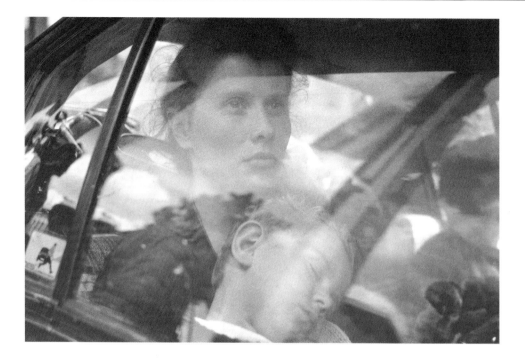

Albanian Kosovar refugees (above and facing page)

The following images demonstrate the different effects of varying degrees of exposure and filtration.

Photographer: Gary Knight.

Technical summary: Ilford Warmtone Semi-Matt, Ilford PQ 1:6 developer at 25°C for two minutes.

Basic print (above)

This print was exposed for 30 seconds at f16, Grade 3. It was too flat for the photographer's taste, but it did expose the detail on the print.

Print 2 (facing page, top)

Again the image was exposed for 30 seconds at f16, but the filtration was increased to Grade 4. During the initial exposure the woman's face and shoulder were held back for -5 seconds each. The top and middle left of the image were also burned. The top of the car was burned for a further +5 seconds to try and frame the subjects.

Print 3 (facing page, bottom)

The same procedure was followed as for print 2, but the top and middle left areas were given more exposure overall. The grade was changed to 2 and the right-hand side and bottom corner were burned. Finally, the small sticker on the left was given a +5 second burn to knock it back. By selecting which areas to bring out and knock back, a feeling of depth and a focus point were created.

In the past there have been limitations in outputting black-and-white digital files. Digital imaging has long been driven by the mass-market need to produce colour images, and black and white was rarely accorded the importance that professional photographers gave it. This meant that there was limited media available to reproduce monochrome prints, and black-and-white prints were often compromised by the need to produce black (and intermediate greys) from colour inks.

The evolution of digital imaging has meant that there are now dedicated inks designed solely for black-and-white printing. Digital manipulation techniques are now also more adept at producing the digital equivalent of toned prints and split tones. Add to this digital's unrivalled abilities when it comes to retouching images, and we have the basis for some very powerful and very effective techniques. This chapter will discuss some of the fundamental retouching techniques that can be applied to digital images and, having perfected the images, how we can emulate – and often exceed – the skills of the darkroom printer in producing toned prints and even fine art productions. The chapter will conclude by looking at how on-screen images can be produced as prints.

'The eyes are not responsible when the mind does the seeing.'
Publilius Syrus

Flower (facing page)
This image was shot on a digital SLR and was converted to black and white using the Channel Mixer. A gradient layer was added to the bottom of the image and highlights were picked out using a brush with 100 per cent opacity.

Photographer: Samman.

Technical summary: Shot using a compact digital camera, colour converted to black and white, imported into iPhoto and converted into greyscale.

Retouching and reconstructing digital images

When the concept of digital image manipulation first appeared, one of the features picked up on by the photographic press was the ability to adjust and correct images that could be improved compositionally. Correspondents felt that it would no longer be necessary for a photographer to get the composition of a photograph perfectly because modifications could be made retrospectively using a computer. They predicted that photographers would be able to change people's expressions, move items around, and add and remove certain elements from an image.

Photographers were originally impressed with these possibilities, however, the assertion that skill could be replaced by technology was clearly wrong. Although digital manipulation allows us to do almost anything with our images, it should only be used for making a good image better, and not as an excuse for a lack of skill or attention at the shooting stage. It is crucial to consider retouching tools as the digital equivalents of the traditional tools – perfect for making modest improvements and only in exceptional circumstances should they be used for anything more.

The Clone/Rubber Stamp tool

The digital tool used for repairing and retouching small details on an image is variously described as the 'Clone' tool or the 'Rubber Stamp'. The latter name tends to be used by Adobe in Photoshop, although the term 'Clone' tool is the most apt and best describes the action.

The Clone tool works by copying the pixels from one part of an image to another. It might, for example, be used to cover a dust mark or blemish by copying pixels from an area immediately adjacent to the blemish, and then using the copied pixels to paint over it. The Clone tool does not remove objects nor move them; it merely paints over areas with pixels from another part of the image.

The following situations may benefit from an application of the Clone tool:

- Removing blemishes, spots or dust marks from any image.
- Removing cosmetic blemishes from a subject's face in portraiture.
- Tidying an image by painting over objects such as telephone wires, TV aerials and satellite dishes.
- Removing ugly street furniture from landscapes.

The Clone tool can also be used between two images, cloning elements of one image on to the other. This is much easier to do in black and white, as with colour images this work would need to be preceded by colour matching of the two images. Otherwise there is likely to be a colour cast that would make the cloned pixels obvious.

Young singer (below and following pages)

The following images show how a distracting gap in the image is removed and retouched using the Clone tool.

Photographer: Peter Cope.

Technical summary: Nikon D200, 70–210mm Nikkor at approximately 150mm, f5.6, ISO 400.

Original image

The Rubber Stamp tool is useful for tidying up images. In this image, the viewer's attention is drawn to the gap in the dark back cloth.

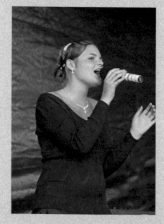

Step 1

By using the Rubber Stamp tool, this gap could be concealed. It is covered up by selecting a part of the scene immediately to the right of the distracting light area.

Step 2

Where the singer's hands cross the light area, care was taken when cloning to prevent the cloned pixels from covering the hand. This was done by making a rough selection (using the Lasso tool) of the remaining sections of the light area to enable imprecise cloning without causing damage.

Step 3

Finally, the remaining areas were cloned over and the microphone stand was removed from the lower left corner.

Step 4

A tighter crop on the singer makes the improvements and adjustments more obvious.

The Healing Brush and Patch tools

The Healing Brush and Patch tools appeared in Photoshop version 7; they represent a more advanced version of the Clone tool. The Healing Brush essentially works in the same way as the Clone tool, but rather than painting opaque pixels over the underlying image it also matches the shading, lighting and texture of the original. The result is more seamless and authentic. This tool is particularly effective when used to retouch portraits. Skin tones in most subjects actually vary much more than might be imagined and can be problematic to repair using a simple clone. The Patch tool can be used to select an area in an object, and paste that selection on an area to be repaired. Like the Healing Brush, the Patch tool will match the texture, colour and brightness of the destination area.

Suited man (below and facing page)

The following images show how Healing Brushes and Patch tools could be used to remove blemishes and improve images such as portraits.

Photographer: Peter Cope.

Technical summary: Nikon F100, Kodak TRI-X, 80mm lens f/11 at 500 seconds.

Original image

Like the Heal tool, the Patch tool can be used to enhance images, particularly portraits. Here, it has been used to subtly conceal the minor wrinkles in the portrait.

Patch tool screengrab

The Patch tool was used to select a small area on the subject's cheek, and this was dragged over the outer eye section to remove the subject's crow's feet and wrinkles.

After Patch tool application

Once the patch is in place, the tone and contrast of the original area (and colour, if working on a colour image) is retained, but the wrinkles are gone. This was then repeated for the other eye, the forehead and cheek.

Reconstructive surgery

More radical changes can also be performed using the Clone tool. For example, a featureless, overcast sky can be replaced with a more visually exciting one from another image. Two, three or even more images can also be combined to create a montage. These compositing techniques do take us to one of the more contentious areas of digital imaging. At what point do we do too much to our original image? Is it still an honest photograph, if compositing two images together to produce one good one has been carried out?

Some photographers would say yes, others no. Some would say that if a technique is possible and it allows the production of a print that looks authentic, it is acceptable. Others are less accepting. Some argue that digital techniques amount to cheating, but others will point out that digital manipulation is no more than an extension of traditional darkroom techniques.

Original image
This shot of the Pierhead Building on Cardiff Waterfront is good, but the sky is rather featureless.

Sky shot
A new sky from this stock shot was used to make the image more dynamic.

The Pierhead Building and sky stock image (above and facing page)
Elements from the above two images were combined to produce the composite image on the facing page using specialist tools in Photoshop.

Photographer: Steve Macleod.

Technical summary: Nikon D200, f11 at 1/250s, 20mm lens.

Composite image

A combination of the Magic Wand and Lasso tools were used to select the sky area of the scene. After selecting and copying the sky image to the clipboard, the Paste Into command was used to paste the sky into the selection area. As the sky image was larger than the landscape, it was moved around to get the best composition.

Noise and sharpening

Once retouching is complete a more general view of the image can be taken. Does it suffer from noise? Is it critically sharp? Have the manipulations done at this stage compromised the image in any way? The chances are that 'yes' will be the answer to at least one of these questions.

Noise

Noise in a digital image can be likened to grain in traditional films. Taking the analogy further, noise tends to get more pronounced at higher ISO speeds, just like film grain. The nature of noise is in the random electrical fluctuations that occur in all electrical circuitry, including those of the imaging sensor. Noise is most commonly seen in flat areas of tone, low light and shadow regions as random colouration of pixels. Sometimes the colour variations are strong, other times less so. Most digital cameras have a noise reduction facility but they are only effective up to a certain point.

It is not always possible to reduce the noise in a digital image to acceptable levels in-camera, so imaging applications such as Adobe Photoshop provide tools to help decrease the effects of noise in an image. These tools can be found in the Filters drop-down menu, and in the Noise submenu. The specific filter tools to use here are Despeckle and Median.

The Median filter will blend pixels within a certain radius and discard those that do not appear similar. This will instantly remove those pixels that are a distinctly different character to their neighbours.

The Despeckle filter locates the edges of image tone and blurs the selected area, yet will leave untouched areas that significantly change in colour. This retains edge sharpness very effectively and avoids some of the softness that can be introduced with the Despeckle filter. In the drop-down menu under Filter, in the Noise submenu the Dust & Scratches option is also available.

If images are blighted by a large amount of fine dust marks or scratches this option can remove them at a stroke, saving a considerable amount of time as compared with using the clone tool. It should be used carefully, however, as it will also do the same for fine detail in the image, rendering the image soft.

Melvich Beach, low tide (facing page and following pages)

The following images of Melvich Beach at low tide show how filter tools such as Despeckle, Median and Dust & Scratches can be used on digital noise to improve the final product.

Photographer: Steve Macleod.

Technical summary: Close-up of image with Despeckle tool applied.

Melvich Beach, low tide: Median screengrab (above)
The Median filter blends pixels within a certain radius.

Melvich Beach, low tide: Despeckle screengrab (below)
The Despeckle filter locates changes in image tone and blends them.

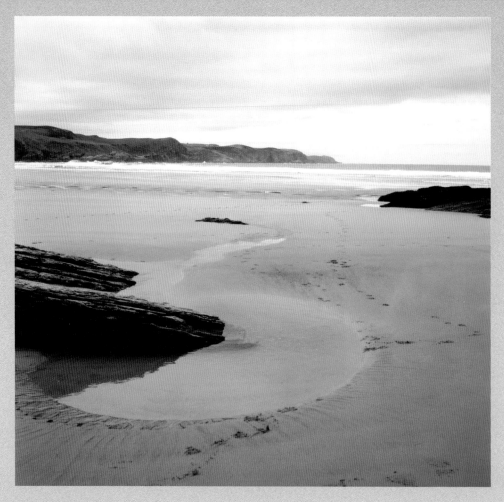

Melvich Beach, low tide

This original was scanned in RGB mode and opened up in the Filter > Noise > Dust & Scratches menu.
The radius value was input to one pixel value in order to minimise the effect of the application. The preview
box is checked to show the effects of the application (see facing page).

**Melvich Beach, low tide: Dust & Scratches
screengrabs, before (left) and after (below)**
Examples showing the evidence of dust and scratches
on a selected area of the image, and the effects of the
Dust & Scratches application.

Sharpening techniques

Another misconception in digital manipulation is that sharpening filters can be used to overcome deficiencies in the sharpness of an original image. Some suggest that if an original image is not sharp enough, then this can be overcome by focusing the image with software. It needs to be made absolutely clear that this cannot be done. Digital manipulation should never be relied on as an excuse for poor practice. What then are the sharpening filters in Photoshop actually for?

Sharpening filters should principally be considered for restoring sharpness to images that might have become a little soft due to the application of other manipulations. Sharpening should be done as a final step before printing. This is because the sharpening process can unintentionally introduce or enhance artefacts in an image. Although these will not necessarily degrade the image noticeably, applying other effects afterwards may do so. For example, if levels were adjusted or contrast boosted, sharpening artefacts would become obvious. It is worth noting that if an image has been split into channels, or the channel mixer has been used in the production of a black-and-white image, the blue channel is more prone to noise – care should be exercised when sharpening this channel.

Unsharp Mask

Of the sharpening filters provided in any software application, only the Unsharp Mask should be considered. The Sharpen and Sharpen More filters allow no degree of control and are indiscriminate in how the sharpening is applied.

The Unsharp Mask, on the other hand, allows for sharpening to be refined. It can be applied in a particular degree appropriate to the subject. For example, the Threshold control in the dialogue box can be used to apply sharpening to the subject of a photograph, but it will not attempt to sharpen an area of continuous tone, such as the sky.

A standard sharpening filter such as Sharpen will also attempt to sharpen the sky and actually only enhance the noise. In fact the Unsharp Mask filter dialogue box offers several options; the amount specifies the quantity of sharpening applied. This should be set proportionately to the resolution of the file. In general, high-resolution files need around 150 per cent. Lower resolution files will need proportionately less. The Radius provides a measurement of how wide the effect will be – the higher the pixel radius, the more obvious the effect. Aim between one and two pixels. The effects can, of course, be modified as they are applied.

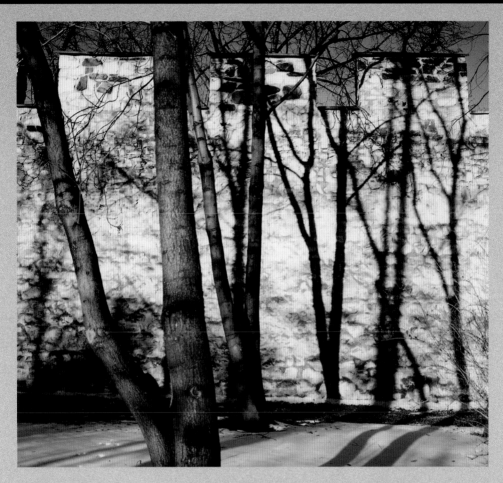

Prague trees (above)

This was originally a scanned colour image. It was converted to black and white via the Channel Mixer before having the Unsharp Mask applied, as shown in the panel on the left.

Photographer: Steve Macleod.

Technical summary: Original colour image converted to greyscale, black and white in Photoshop.

Creating tones

Once an image has been converted from colour to black and white, it can also be adjusted digitally to recreate the effects of conventional darkroom processes. It is important to be sensitive to the image and only use toning effects to support the originally strong image. There are several ways in which the colour and tone of a black-and-white image can be adjusted. The Channel Mixer is a way of fine tuning and controlling subtle colour; however, this takes some time to master. An easier route to start with is the Colour Balance menu.

Colour Balance

The Colour Balance control was initially provided to allow photographers to correct colour balance in an image. By using an incorrect colour or white balance setting on a digital camera, it is possible to end up with colour casts on images. However, these can be easily remedied by using the sliders on the Colour Balance control. It is also useful for producing toned black-and-white images. When the Colour Balance submenu is opened the Colour Levels and the three sliders for channels can be set. These adjustments can be made in relation to the shadow, mid-tone and highlight values of the file, so that a multitude of colour interpretations can be formed. A good point of reference is to study and recreate traditionally toned prints.

Adjustment Layer

Toned black-and-white images can be created using an adjustment layer. Adjustment layers are good to work with because effects and filters can be applied to various layers, which will not damage or affect the original image in any way. Should the results of these manipulations be unacceptable, the Adjustment Layer can simply be discarded. The effects applied to the image on the facing page can be created as follows:

- Open up a new adjustment layer from the palette by clicking on the Adjustment Layer button at the base of the Layers Palette. This will bring up a default menu.
- Click on the Preserve Luminosity box.
- For this image, Shadow Values were adjusted first.
- Next the mid-tone values were adjusted, making them slightly colder than the shadows to subtly increase the effect of the split. Finally, the highlights were altered, making them colder still, which is something that would normally happen when a print is selenium-toned.

In order to convey a cold and flat day in Krakow (see page 144–145) the original RGB file was converted to greyscale using the Channel Mixer. A New Levels menu was then created, and the output highlight value was adjusted to 253. The output shadow value was set to six, in order to compensate for any contrast increase and consequent loss of shadow detail in toning.

Next, a new Colour Balance Adjustment Layer was created. The mid-tones were then adjusted, making them more blue in tone, leaving the green and red channels untouched. The blue values in the highlights were increased, as well as the green to warm up the colour slightly. The shadow levels were left alone in order to ensure a good black was maintained – providing the same result as a traditional blue toner.

Thai lily, toned print (below)

The idea behind this image was to create a strong selenium split-toned effect. The toner traditionally affects the shadow regions first and then works through the mid-tones towards the highlights. Black-and-white values in the highlights and mid-tones were retained, and shadows were coloured to achieve the look of a traditional print.

Photographer: Steve Macleod.

Technical summary: Not available.

Snowsteps, Krakow (below and facing page)

The following images show how the Colour Balance and Adjustment layers can be manipulated in Photoshop in order to create images and prints that have a traditionally processed look and feel.

Photographer: Steve Macleod.

Technical summary: Shot and scanned from the negative. Edited in Photoshop and giclee printed.

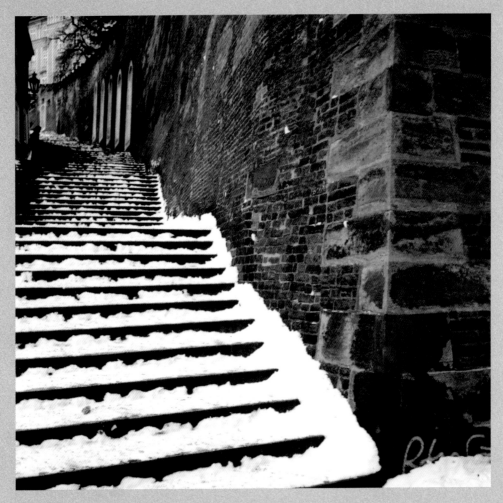

Original image

This is the colour scan of the original image, which was scanned in RGB.

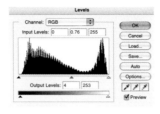

Colour-adjusted image

The final, colour-adjusted image. The Colour Balance pop-up above shows the channel sliders that affect the colour space of the file. The balance of shadows, mid-tones and highlights can all be altered separately. The Levels panel shows the relationship between the different channels, and the histogram can be compared against the colour balance of the file.

Split toning

Digital split toning is easily achieved; in many ways it is more controllable than the methodology employed in the conventional darkroom.

The following image was converted using the Channel Mixer in monochrome mode: Image > Adjustments > Channel Mixer. The red channel was set to 120 per cent and blue to -30 per cent to increase the density and contrast of the original image. A new Colour Balance Adjustment Layer was then added (as described previously) and the shadow and mid-tone values adjusted. The aim was to try and create a selenium-type tone.

For the second tone, a second Colour Balance Adjustment Layer was added and this time only the mid-tone and highlight values were adjusted. The effect was to try and create a digital equivalent to a standard thiocarbamide tone in the highlights. Using the Layers palette, the sliders could then be moved in order to vary the transparency of the layers and blend the two together, smoothing the transition to create the split-tone effect.

Original image
The original colour image before split toning was applied.

Prague landscape (below and facing page)

By comparing the original and final results of this landscape image, it is possible to see the effect of split toning.

Photographer: Steve Macleod.

Technical summary: The following image was converted using the Channel Mixer in Monochrome mode: Image > Adjustments > Channel Mixer.

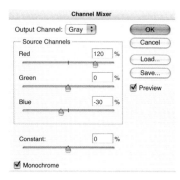

Channel Mixer adjustments applied

In order to create a selenium-type tone the red channel was set to 120 per cent and the blue channel to -30. This increases the density and contrast in the original image.

Final image

The split-toning effect was achieved by creating two different colour balance adjustments merged together to create a smooth, tonal transition.

Duotone and tritone images in Photoshop

Another way to create split-toned prints is to use the duotone technique in Photoshop. Normally a duotone would comprise a nominally black-and-white image toned with black and one other colour. For best impact the second colour needs to be at a different density. Tritones have three colours in the tone and quadtones have four. It is fun to experiment with tritones and quadtones, but better results will often be obtained with a duotone.

Duotone images can be created in Photoshop by either using a preferred combination of tones, or using some presets that Photoshop (advised by some of the leading exponents of this technique) have provided for users. These are outlined on the facing page.

Girl (below and following pages)

The following images show the original image and the effects of duotone, tritone and a second colour application.

Photographer: Peter Cope.

Technical summary: Fujifilm S1 Pro camera, 80mm f5.6, Effective ISO 160.

Girl: Green channel

This image was originally shot in colour but was then split into channels. This is the Green channel.

- Begin the process by selecting Image > Mode > Duotone. Note that this can only be done if the image has been created as, or converted to, greyscale.
- In the dialogue box use the drop-down menu to select Duotone (it is set to monotone by default; this menu also gives the option of selecting tritones and quadtones).
- Select the Load button. This allows the user to select from the range of pre-configured duotone colours, including grey and black tones, pantone-based tones and process duotones (these are still closely based on the combinations that are conventionally available to the printing industry).
- Select a duotone – it will appear in the main dialogue box, and the effect will be immediately applied to the image.
- Next, click on the small graph box. A dialogue box will open with a large graph similar to the Curves graph explored earlier.
- If required, the curve can now be modified to change the balance between the two tones in the image. It is also possible to click on the adjacent colour patch and change this, should there be a change in the tone of the colours desired.

Girl: Duotone

The Image mode was converted to duotone by selecting Image > Mode > Duotone. A preset duotone, Pantone 502c, was applied to give this delicate cerise/fuscia duotone. Careful adjustment of the Curves graph in the duotone dialogue box allowed for subtle colouration.

Girl: Tritone

Selecting the Tritone option enabled the addition of a second colour – Pantone Yellow C. This was chosen by clicking on the small square to the left of the Curves graph.

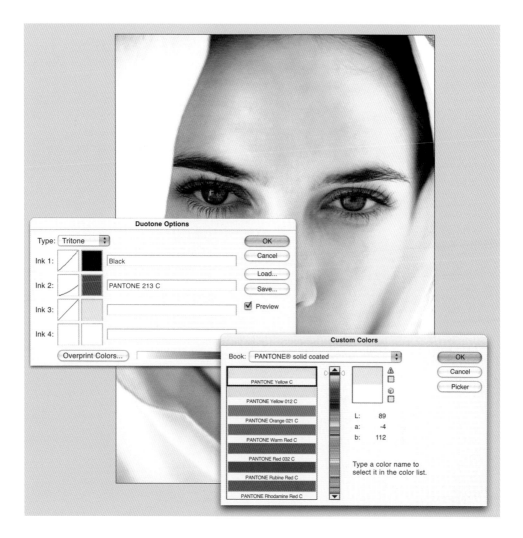

Girl: Application of second colour

Applying the second colour gives this warm, gentle sepia tone.

Inkjet printing

In the digital darkroom manipulations to images are conducted live on the computer screen. When all corrections and changes have been made the image is saved and, should the photographer want a print, the file is sent to a printer for printing. Unlike the conventional darkroom method where the production of the print itself is a major part of the process, producing a digital print is an automated function. However, in order to produce a successful print, a printer that is up to the job and correctly configured will be vital. Similarly, the quality of inks and papers used will have a big effect on the standard of prints.

Printers

Such have been the advances in inkjet design over the years that even fairly simple and cheap printers are capable of producing good photographic prints. However, in order to produce great prints, a printer capable of exacting standards will be required. Inkjet photo printers are widely available in A4 and A3 sizes; larger printers are also available. However, unless there is a specific need to produce prints of A2 or A1 size regularly, it is unnecessary to invest in one of these – files can easily be taken into specialist printers instead.

Inks

A basic printer will feature three ink colours: cyan, magenta and yellow. Others may add black to this selection to offer true CMYK printing. Photographic printers may have more inks. Depending on the model, you may find light magenta and light cyan added. Light black (grey) and other intermediate colours may also be provided in a quest to produce the most authentic images. Some printers also feature ink sets specially designed for printing photographs on to photographic paper. Ink sets offering the best performance for printing day-to-day material are not necessarily the best for printing glossy photos.

Black-and-white images are rarely produced by the general user and when they are, the user will be quite satisfied with the results from the standard ink sets. However, a more critical examination of such images will show that they compare unfavourably with conventional prints. In order to get the best black-and-white results, it is wise to invest in special black-and-white ink sets. These replace not only the blacks of the standard ink sets but the other colours too. They are surprisingly widely available, both as replacements for the standard ink cartridges and as continuous feed systems.

To keep printers running continuously, externally mounted ink tanks of high capacity can be used, which feed directly to the print heads. Although not a cheap installation, it does pay dividends in the long run, cutting down on the onerous cost of individual cartridges. As well as different ink delivery systems and colour/tone combinations, there are several different types of inks available:

Dye-based inks are made up of water, glycol and colour dyes. There is an archival selection available, which performs better than ordinary inks.

Pigmented inks combine UV-protected pigment ink with ordinary dye colours. Very good results can be achieved on all but glossy surfaces, where irregular absorption can be an issue; the effect is an uneven gloss to the print.

Full-pigment inks contain little or no dye elements. Pigment is relatively insoluble so the colour-reflective qualities are improved. However, like the other types, no inkjet methods are permanent – they are classed as fugitive processes as they will fade with time.

Papers

Every printer manufacturer has their own paper range. A wide range of third party manufacturers also proclaim improved archival stability and image quality when partner inks and papers are used. This may be true, but do not be afraid to experiment with different combinations. As with darkroom printing, find a solution that works for you and use media that is sensitive to the original image. Also, black-and-white images often look better on matt or semi-matt surfaces, as light is absorbed into the print and blacks translate more sensitively.

Inkjet photographic paper is also categorised by its surface and can range from glossy, photo, silk, matt and art, and will provide many variations of finish. Archival stability is another issue that is still in question, particularly with print collectors. Manufacturers recommend using their ink and paper combinations to maximise image stability, but the paper should be cotton-based, wood-free or a combination of both. Get the combination of paper and ink right, and black-and-white images can look every bit as good as conventional darkroom prints.

dye-based inks inks made up of water, glycol and colour dyes
pigmented inks inks that combine UV-protected pigment ink with ordinary dye colours
full pigment inks contain little or no dye elements; the colour-reflective qualities are improved as pigment is insoluble

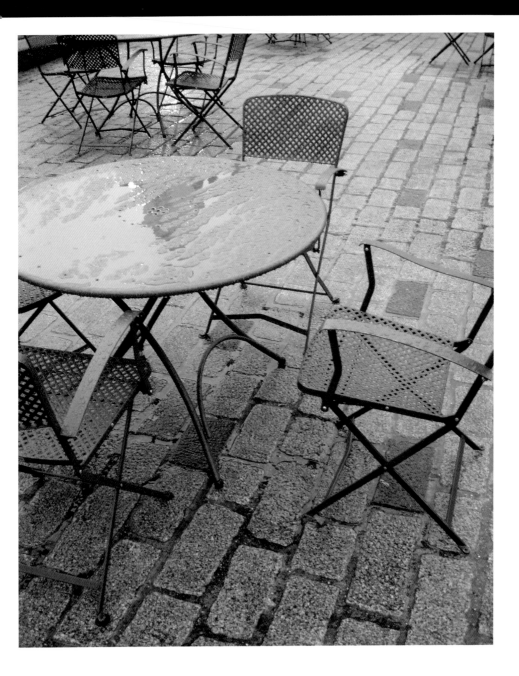

Chairs (above)

This image was shot on a miserable winter's day and was printed with dark and heavy tones to convey a bleak and sombre mood.

Photographer: Steve Macleod.

Technical summary: Scanned from colour negative, split-toned in Photoshop and produced as a giclee print.

Printer calibration and colour casts

Often what is seen on the screen is not what comes out of the printer. More often than not, this means that the display monitor and printer are not profiled or calibrated correctly. ICC profiles specific to the type of printer and paper used can be purchased and used. If this is not available then a manual method of calibration is possible using the printer driver applications.

When using a colour set of inks there is a risk that the image may be printed with having a colour bias and a change in image temperature. If the image is printed in greyscale, only the black ink will be used, and there is the risk that the print quality will not be as good.

When using a colour set of inks to print monochrome, and the output print has a cast, try adjusting the printer settings to cancel out the effect of any bias. This method can also be used to increase or decrease the density of the print by adjusting the volume of black ink used. When using black ink only, it may be possible to still see a colour cast. This is due to the reaction between the ink and the selected paper. The solution to this problem is to change paper stock or to print in colour and counteract any bias.

Another useful method for making colour cast adjustments is to refer back to the Variations application in Photoshop. Once the image is printed and there is an obvious colour shift, duplicate the file and open up the Variations pop-up. Compare the print to the Variations selections, find the option that is closest in colour to the output, and check its opposite companion. Click on this and output that variation – the result should be to cancel out the original colour bias. If there is still a tint to the image, the opacity of the corrected layer can be decreased again in an attempt to rectify the issue.

'Photography, as a powerful medium of expression and communication, offers an infinite variety of perception, interpretation and execution.'
Ansel Adams

Colour Variation screengrab (above)

A typical colour variations 'wheel' showing the original image with percentage shifts in RGB channels. It is also possible to view these as shadows, mid-tones or highlights.

Printer screengrab (below)

This is the manual printer option for the Epson Photo R300. The gamma, brightness and colour levels can all be adjusted at this stage.

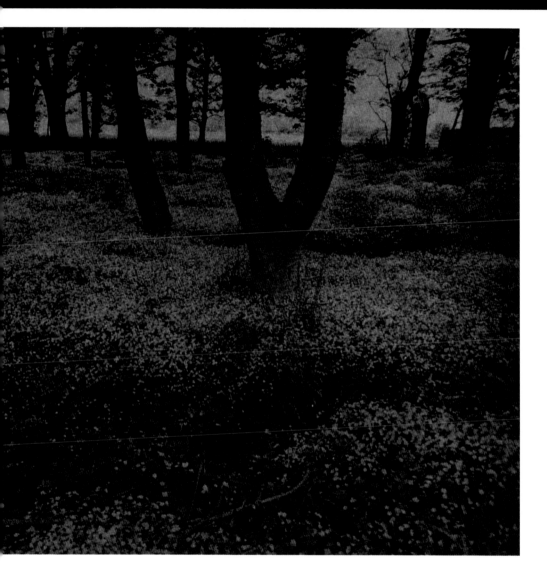

Woods (above)

The above was produced conventionally as a neutral lith print. The image has a warm tint to it and was printed using colour inks rather than solely in black in order to enhance any colour bias from the original.

Photographer: Steve Macleod.

Technical summary: Scanned from original 10'' x 8'' lith print and reproduced as a 20'' x 30'' giclee print.

Good photographers achieve their success on several counts. Firstly, and perhaps obviously, they have the skill to shoot technically perfect photographs. They also have the creative skill and vision to interpret ideas or a brief. Finally, they are able to produce an exceptional end product. The same is true of all good photographers, but what is the difference between a good photographer and a great one?

Some less successful photographers fall at the final hurdle. In spite of being able to produce top-notch imagery, they let themselves down in the way they present their work. If photographs and materials are not showcased in the best way possible, they will do neither the photographer nor their clients (or potential clients) justice. We conclude by looking at some of the key ways in which photographers can promote their work to the wider world, ensuring that they give themselves the best chance of successfully securing a commission.

'I am a photographer in the way you might be a plumber. I like it that way...'
Bruce Davidson

Skye, Black Bull (facing page)
This image was exposed through a sheet of Muslin to add texture. It was then lith-printed to exaggerate the grain and contrast of the print. The print was scanned in RGB and cleaned up. It was then reprinted on to a cotton rag, textured watercolour paper. The edition was sold as an edition of five.

Photographer: Steve Macleod.

Technical summary: Scanned lith print imported in Photoshop.

Websites

It used to be true that a client would choose a photographer for an assignment based on the strength of their portfolio. The portfolio would command strong physical presence in the hands of the client, and allow the client to look in detail at the quality of the photographer's work. Today most professional photographers have a web presence and generally, websites are what prospective clients will look at first. Websites will not necessarily replace an actual portfolio or formal presentation, but they can act as a pre-selection tool to shortlist photographers that might proffer work meeting the intended brief most closely. A photographer's website must grab the attention of a visitor through the quality of images, but it must also make it easy for them to discover more about the photographer and the way they work.

Author's tip

Successful websites depend on good design and allow for ease of use. Visitors must be able to glean all the necessary information within them in the most expedient manner. These are some issues worth considering when putting together an initial website outline:

Images

Visitors will principally come for the images; everything else will be subsidiary. Images should be clearly presented and offer obvious cues as to the style and the range of subjects covered. Present a number of images on screen simultaneously, or present selected images, full screen. It is essential that visitors can examine selected images in detail and get an overview of many images.

Navigation

Easy navigation is crucial for visitors to the site. Guests should be able to find images, search the website and find out more information by using simple button clicks. Avoid complex navigational tools – simple, user-friendly sites are best.

Personal information

Information about the photographer and the scope of their work should also be presented clearly. Reinforce credentials by giving details of any previous assignments, a client list (if available) or anything else that will help make a judgement for suitability easier. Include contact information – email addresses, actual, physical addresses and phone numbers should all be available.

Music

Opinion is divided on the inclusion of music with a website. After all, the aim is to focus attention on the images. However, carefully chosen background music can often contribute to the creation of a relaxing environment for visitors to browse the website. If music is included, make sure that there is an option for the user to turn the sound on or off.

Creating a website

Constructing a website for the first time may seem a daunting task. In fact, a basic website can be put together very quickly and very simply. Applications such as Apple's iWeb, for example, allow the user to construct professional-looking websites that can even include galleries of images from a collection. However, photographers aiming for a higher standard are better off opting for something even more professional and credible. Two things need to be considered carefully when pursuing this option. Should time be invested in designing, producing and managing a website? Or should it be spent putting together the best images to populate their web space? Fortunately, many companies produce websites for photographers, enabling them to choose the latter of the two options. They will take a brief from the client and then deliver a site that is both professional and effective.

Getting a name for yourself

Visitors access sites by typing in a web address in the form <www.name.com> or <www.name.co.uk>. Some photographers also use their own names or studio names. If the creation of the website is sub-contracted to an agency they may take care of this for the client. Otherwise it will be necessary to visit a site that specialises in setting up web addresses. These sites allow for the testing of different names. Try a few alternatives if the first choice is already taken, but do aim to make the name something memorable. Once a name has been chosen, the web address based on it can be purchased. Once the purchase is approved, any traffic that goes to this address will be directed to the website. This can all be arranged where the address name was purchased.

'The magic of photography is metaphysical. What you see in the photograph isn't what you saw at the time. The real skill of photography is organised visual lying.'
Terence Donovan

Promoting yourself and your website

Once a web address has been found and the website created, it is vital to get people visiting. It is a good idea to set the website up so that when anyone enters relevant data into a web search engine – such as the photographer's name, the studio name or even their photographic areas of expertise – the site is listed and appears as a search result.

As search engines continue to search, catalogue and cross reference web pages over the first few weeks or months, the effectiveness will increase. However, if quicker access is needed and in order to appear higher on lists in a shorter amount of time, it may be easiest to go back to the agency for more proactive help.

Apart from creating a presence on web search engines, there are also other ways to promote your work and expertise, which might include:

- Straightforward advertising in the specialist press.

- Newsletters.

- Links from and to other photographic websites (reciprocal arrangements).

- Submitting details to key trade directories.

Promotion is a hard and sometimes lonely task but it will ultimately pay off and allow you to reap the rewards of your work.

'Photography can be a mirror and reflect life as it is, but I also think it is possible to walk, like Alice, through the looking glass and find another kind of world within the camera.'
Tony Ray Jones

Hamish Brown

Biography
On-line portfolio
Editorial
Sport
Luis Figo
Actors
Robbie Williams
Music
Cover Artwork
Contact

Next Page

HBW screengrab

Hamish has had several website designs over the years and the current site is mature, clean and above all, very user-friendly. It engages the viewer to have a look at several different aspects of his work.

www.hamishbrown.com

Print portfolios

The type of portfolio should reflect the type of work produced by the photographer. However, most photographers may not concentrate on a specific photographic genre so it may be worth considering producing two or more different portfolios, each aimed at a respective market. This is where inkjet printing is such a boon – it is possible to produce a portfolio that includes only the most relevant images from a collection, and include perhaps only a page or two at the end to show the breadth of other material that might be on offer.

Agents hold several copies of the portfolios and will re-arrange and update these depending on the brief and commissions that arrive. It is a good idea to issue agents with new images as appropriate and as they become available. Keep refreshing your material: a client may see the same images on more than one occasion, so it is crucial that they see the photographer as busy and always able to supply new material.

There is a fine line between fulfilling the brief and providing a taste of something different. Remember to only include material relevant to the pitch, as this is all that is of interest. Most art directors are on a schedule and they too have a brief – they have to choose an image-maker who can deliver. To start building relationships, it is important to gain trust right from the beginning – do this by following a brief, listen to what is being asked for and deliver on time, within budget.

'Not everybody trusts paintings, but people believe photographs.'
Ansel Adams

Boy (facing page)

This image was printed as part of a story on Camden Life. The collection was presented in a print folio box, with loose-sleeved prints.

Photographer: Fredrik Clement.

Technical summary: 5'' x 4'' MPP camera, Polaroid Type 55 negative, printed on Agfa Multicontrast, split-toned selenium.

Portfolio presentation

Portfolios come in many shapes and sizes – from bound books with plastic sleeves to archival boxes where prints are loosely displayed. Some photographers prefer CD and DVD presentations. However, these should only be supplied if the client has suggested these will be acceptable. This method of presentation is often considered less successful as clients still like to see physical evidence of how work is presented and, potentially, how the work they commission will be presented.

From the very beginning of this book it has been stressed that planning and attention to detail are fundamental to working practice; this should also manifest itself in portfolio and work presentation. Images should not only represent a photographer's finest work; they must be displayed well too. Bear in mind the relationship between the image, the print media and the viewer. Consider the abuse that a portfolio might be subject to. Portfolios get worn and damaged as they are frequently inspected and handled; keep them up-to-date and replace damaged or non-relevant images. It is true that a well-thumbed portfolio suggests a popular photographer, but most clients would prefer to see a pristine new collection.

A gift for your client

Thanks to the pervasive nature of digital imaging, it is now easy and relatively cheap to produce hard bound books of images. All the main commercial laboratories can do this and they can also configure an album as a formal portfolio. It is worth considering producing a mini-portfolio of work to act as an aide memoire for prospective clients.

Author's tip

Don't make the portfolio too big and keep the content to about 15–20 images. Clients, like anyone else, can get bored, particularly if they have several portfolios to review. Make it flow: start strong, ease up a little with some fillers, peak again in the middle, drop slightly and finish on a high. Keep the viewer engaged and wanting more.

Legs on a chair (facing page)

This image was printed on Forte Polywarmtone and was not meant for portfolio use as it was presented traditionally. However, it could be presented in a different way and it works well displayed in a frame.

Photographer: Sarah Knight.

Technical summary: 645 camera, Kodak PLUS-X125 film, printed on Forte Polywarmtone.

Personal presentation

Any opportunity to present a portfolio in person should be taken advantage of. Bear in mind that clients will make judgments on material sent to them or viewed on a website; the fact that they have asked to see a photographer in person suggests that they may have something special to work with that needs something more specific and customised.

Approaching a presentation

The way in which presentations are approached is very important. Clients will already have been convinced by photographic professionalism, so the photographer will now need to demonstrate to them that they are also professional in a business and personal sense. It is important to be clear and confident during the presentation: dress smartly but in accordance with the client; have an understanding of why you have been called to present your work.

During the meeting, the client needs to be convinced that you are capable of achieving the results they require. Do not be afraid of asking the client what he or she would like to get out of the meeting. This is a very professional approach, which demonstrates that you do not want to waste their time on anything that might be irrelevant.

Digital presentation

A presentation to a client may also be done digitally in order to supplement a conventional image presentation. This can be done with the use of a laptop, which can be brought to the meeting or projected on to a screen in a commercial environment. The material chosen for the digital presentation should complement any other material the client has seen previously.

Be sensitive to the client's needs and reactions. If the client has commented favourably on a particular type of image, it would make good sense to show variations of the same subject or theme. You could also take advantage of this opportunity to demonstrate what else you are capable of. Some photographers travel to clients with a laptop computer and a series of alternate presentations in order to mix and match according to the needs of the client.

'The hardest thing in photography is to create a simple image.'
Anne Geddes

Keynote screengrab

With Keynote, images can be
imported for a slide show, while
text and audio can be added.
There are numerous themes
and views available so the whole
package can be customised
to suit the subject and
the audience.

Author's tip

The collection of high quality photographic images as art has seen exponential growth in the UK in recent
years. This is very encouraging because for years the UK lagged behind the USA and Europe in the
appreciation of photography as an art form. Driving this increased interest are artists such as Darken Almond,
Sam Tailor-Wood and Gillion Wearing. These artists use photography as an extension of their work, making
photographic prints available to an increasingly appreciative market. The willingness of people to collect prints
also means that their expectations and demands are becoming greater. Exhibiting work is a whole different
sector to commercial commissions, but it is not something that should be regarded as the preserve only of the
most reputable of names. Any competent photographer could, and indeed should, consider approaching
gallery curators in the same way that commercial commissions would be approached. Spend a little time on
researching the type and scale of work that galleries have exhibited in the past. It will be necessary to provide a
thesis and biography in support of your work. Be prepared to lose between 30 and 50% of any profit made
from sales.

As with other printing processes, photographic prints are often sold to collectors as edition prints with artists'
proofs. Edition runs and print dimensions must be set prior to printing; the cataloguing of editions sold must be
kept up to date. Any serious collector will expect to be able to trace a print's history. Don't be tempted to make
large edition runs of prints – start with runs of either 15 or 20, while staggering the issue of the editions. It is not
necessary to have them all printed at once either; the 'on demand' approach (where the print is made once
ordered) is possible, but be sure to keep a record of the edition as it sells.

One of the greatest considerations to keep in mind is archival stability. This is the very reason why collectors
are still shying away from ink- or dye-based media. These processes have no history of archival stability in
spite of reassurances from manufacturers. However, the manufacturers have reputations to maintain and have
subjected their media to accelerated life cycles, so it is reasonable to believe that their projections are
accurate. When presenting prints to a collection ensure that each print is editioned and signed and, if
appropriate, provide a certificate of authenticity and information about the method of production.

Conclusion　▷

The past decade has been somewhat tumultuous in the world of the photography. The advent of digital techniques and technologies breathed new life into the art and practice. I find it intriguing that, in the space of a few years, the act of taking photographs has moved on from being something of a minority activity to one that virtually everyone is – to a greater or lesser extent – able to enjoy and take part in. Whether it is a simple compact, a camera phone or something more sophisticated, cameras have become more or less an essential part of our lives.

What does this mean for us? First there is a greater awareness in general: people are more aware of photography and photographs. There is, in particular, a greater appreciation of a 'good' photograph – one that has been well-composed and exposed in-camera and, subsequently, well-printed.

At no time in the history of photography has the photographer had such a choice in the equipment used to shoot photographs or, subsequently, to produce images from the photographs shot.

There is a fallacious belief that digital photography has, in a sense, railroaded its way through the world of photography and, in the minds of many, cast aside the traditional methods and methodology. Photographs today can be shot with just a nod to good technique, and then easily manipulated into something significant in the digital darkroom.

Of course, that conviction is entirely wrong. For a start the traditional methods of producing prints, black-and-white prints in particular, are as valid today as they ever were. The greatest exponents of print production, even if they now work in the digital domain, will stress how the techniques of the conventional darkroom underpin everything they do today. It goes further: an understanding of the principles of the darkroom stand you in good stead for understanding the mechanics of lighting when you are composing and shooting images.

The popular press often speak of the 'digital revolution', particularly with regard to photography. However, photography encompasses much more than digital technology; it is better described as an evolution. To become an accomplished photographer you need the skills to produce a good photograph, and the ability to implement those skills. This requires a command of conventional and digital techniques, and the ability to discriminate and assess which offers the best opportunities for a specific situation.

Becoming a great photographer is not about having the latest and best equipment – it is about developing a good eye and skills. Armed with these you can set about letting the world know about yourself through self promotion. This is not always a skill that comes naturally to any of us, but with a strong portfolio to support your efforts you will be well on the way to establishing yourself as a photographer.

Untitled (above)

This light and summery image was taken as part of a feature fashion and beauty shot for Red magazine.

Photographer: Jamie Kingham.

Technical summary: Kodak PLUS-X 125, rated normal processed at +1/2, printed on Ilford Warmtone Glossy.

AE
See Automatic exposure.

Analogue
A method of recording data in its original form in a continuously varying way, rather than in numerical form as in digital recording. Conventional film photography is an example of analogue data recording.

Angle of view
The angle across a scene that a camera lens covers. It is measured across the diagonal of the frame.

Aperture
The opening in a camera lens, which allows light though. An iris diaphragm is adjusted to vary the aperture, in conjunction with adjustments to the shutter speed, to deliver the correct exposure.

Aperture priority mode
An exposure mode where the photographer selects the aperture while the camera sets a corresponding shutter speed.

Aspect ratio
The ratio of the width of a frame of photographic film frame (or a digital sensor) to its height. It can also be used to describe the same ratio in a photographic print.

Automatic exposure
A camera setting on digital and film cameras where the camera automatically sets both the aperture and shutter speed for an accurate exposure.

Baseboard
The part of an enlarger where the photographic paper or the easel is placed.

Bridge camera
See Hybrid camera.

Burst mode
The ability to shoot a number of images in close succession in a digital camera. This can be compared with the motor drive capabilities of a film camera.

Camera phone
A mobile (cellular) telephone that incorporates a camera.

Card reader
A device allowing the memory cards from a camera to be read by a computer.

Centre weighted metering
A camera metering system that biases the metering towards the centre part of the frame on the basis that this is where the subject is likely to be placed. This is the default setting in many cameras.

Charge coupled device (CCD)
An imaging sensor used in many digital cameras.

Cloning
A digital technique used for copying pixels from one location to another. Often used to hide marks and blemishes or to add new elements into an image.

CMOS image sensor (CMOS)
An image sensor using alternate technology to the CCD. It is preferred for some situations because of its lower power consumption.

Colour balance
See White balance.

Colour head
The top component of an enlarger including the lens, condenser and lamp, which also includes the colour filters required for printing colour prints. Can also be used for producing black-and-white prints.

Compression
A way of storing a digital image file by first compressing the data to allow more image files to be stored on a memory card.

Compression, lossless
A type of digital file compression that compresses a file without losing any of the original data or compromising image quality. The image, when decompressed is, identical to the original.

Compression, lossy
A type of file compression that compresses a file to a much greater degree than the lossless compression. This is done by discarding some of the data. When the image is restored there is a drop in quality proportional to the amount of compression.

Condenser
The component of an enlarger that refines the light source to provide even illumination.

Cropping
The process of trimming a digital or conventional image to remove unwanted parts or alter the composition.

Depth of field
The distance between the nearest and farthest points that appear in acceptably sharp focus in a photograph. Depth of field varies with lens aperture, focal length, and camera-to-subject distance. This can be enhanced by digital techniques in post-production.

Developer
Photographic chemical designed to develop the latent image in a photographic film or paper, rendering the image visible.

Developing tank
The light-tight tank used to develop photographic film and sometimes individual sheets of paper.

Digital
The representation of data (image, video or audio track) as a digital code, which can be interpreted by a computer. Unlike analogue, this code can be easily and effectively copied and modified.

Dodge and burn
A darkroom technique for lightening (dodging) or darkening (burning) areas of an image by selectively lessening or increasing (respectively) the amount of light the paper is exposed to. This is also the name of an equivalent digital technique.

Downloading
The process of transferring images from a camera to a computer.

DPI (dots per inch)
The measure of the resolution of a scanner. Higher DPIs mean higher resolution scans.

DSLR
Digital SLR – see SLR.

Duotone
An image produced by combining two colour channels in an image; often used to produce digitally-toned images.

Dye sublimation printer
A type of printer that uses a variable heat source to transfer dyes to a special type of paper. Generally capable of high-quality printing.

Easel
The component of an enlarger resting on the baseboard; it is used to hold the photographic paper firmly in place.

Electronic viewfinder
A viewfinder found in hybrid digital cameras that uses a small LCD panel behind a conventional viewfinder eyepiece.

Enlarger
A darkroom device used for enlarging negatives or transparencies for printing on photographic paper.

Exposure
A measure of the amount of light falling on the film or the digital image sensor of a camera when taking a photograph. It can be 'corrected' by adjusting the aperture and the shutter speed.

Exposure compensation
The adjustment of a metered exposure to allow more or less light through to the sensor in order to compensate for the brightness or reflectivity of the subject. Exposure could be reduced to properly expose dark subjects. Normally used to describe an in-camera technique but also applies to darkroom (digital and conventional) enhancements.

Exposure / focus lock
A feature found on some top compacts and SLRs that allows the exposure settings or the focus to be locked by pressing either the shutter release partially, or depressing a separate button.

Firewire
A fast data transfer system used for downloading digital images. Also called IEEE 1394 and i.Link on Sony equipment.

Fixer
A chemical used in film and paper processing designed to dissolve away unused components of the photographic emulsion.

Focal length
A measure of the distance between the centre of the outermost lens element of a camera lens to the film plane or imaging sensor when the camera is focused at infinity. It is normally expressed in millimetres.

Focus
The point where the light rays from a subject are brought together to form an image on the film or sensor or on the baseboard of an enlarger.

f-stop
A standardised measure of the opening of a lens aperture. Each subsequent f-stop (when numerically increasing) represents an aperture one half of the previous (e.g. f2, f2.8, f4, f5.6).

Greyscale
A scale of 256 discrete tones used in digital imaging. Black is represented as tone 0 and white as tone 255. It is also used to denote a monochrome (black, white and grey) image.

Highlight
The brightest part of an image. In a digital image it is represented by tone 255 on the tonal scale.

Hybrid camera
An informal name used to describe cameras that are ostensibly compact in design but have some features and specifications found on SLR cameras.

Image manipulation application
Software designed for the manipulation and editing of digital images. Photoshop is the most renowned of these. Sometimes called image editing application.

Image sensor
The component of a digital camera analogous to the film in conventional cameras. It is an electronic device used to convert an image into an electrical signal. Comprises an array of pixels each having a light-sensitive area called a photosite.

Inkjet printer
A computer printer that uses a technique where minute quantities of ink are sprayed on to paper. Many inkjet printers can produce photographic prints but some – those with more ink colours – offer a far higher quality of printing.

Interpolation
The process of mathematically increasing the number of pixels in a digital image. Intermediate pixel values are calculated from those either side. Interpolated images do not offer any more detail or resolution than the source image sensor.

Inverse square law
In photography, an interpretation of the law of physics in which the intensity of light falls with the increase in distance: if you double the distance, intensity will fall by a factor of four. An awareness of this principle is required to calculate attenuation of flash light when shooting photographs, and when adjusting the head of an enlarger for correct exposure.

iPhoto
Photo downloading, cataloguing, storage and manipulation application found on all Macintosh computers.

ISO
International Standards Organisation. In photography it is used to denote the sensitivity of film and the equivalent sensitivity of an image sensor. Higher numbers indicate higher sensitivity. This has superseded the previous (and identically scaled) ASA rating.

JPEG
Short for Joint Photographic Experts Group. It is also the name of a file format used to store images on memory cards and computers. It allows files to be heavily compressed, but at the expense of absolute quality (lossy compression).

LCD monitor screen
The screen found at the back of digital cameras used to preview images and review photos recorded by the camera. Also found on some inkjet printers for displaying images on a memory card.

Matrix metering
A camera metering system (digital and conventional) that evaluates the exposure at a large number of points across the scene before determining an overall exposure.

Megapixel
One million pixels. Used to describe image sensors (i.e. 5 megapixels = 5 million pixels).

Multiple exposure
A single image comprising two or more image exposures that are superimposed in-camera. Similar effects can be produced digitally using computer-based image manipulation software and through consecutive exposures in an enlarger.

Noise
Interference produced by random fluctuations in an electronic circuit in digital photography. Most obvious in digital images recorded using high ISO settings.

Optical viewfinder
Camera viewfinder that relays an actual image (rather than an electronic image) to the eyepiece.

Overexposure
When too much light is allowed to reach the film, sensor, or photographic paper in an enlarger in comparison to the assessed exposure. This may be done accidentally or intentionally for creative purposes.

Photoshop
Image manipulation application produced by Adobe – the leading application used by virtually all professionals and enthusiasts.

Photosite
The small light-sensitive central area of a pixel on an image sensor, which records the brightness and colour information. Some pixels (such as the Fujifilm Super CCD) use two photosites for each pixel to record better brightness information.

Pixelation
Occurs when a digital image, or part of a digital image, is enlarged to more than an acceptable level making the individual pixels comprising the image visible.

Pixels
Contraction of 'picture element'; the individual elements that comprise an image sensor and, consequently, a digital image.

Programme exposure
An automatic exposure system where aperture and shutter speed are set according to a programme optimised for the majority of shooting situations.

Quadtone
An image produced by combining four colour channels in an image; often used to produce digitally-toned black-and-white images.

Rangefinder
A camera design, normally manual, that uses a triangulation system to determine subject distance and focusing.

RAW format
An image produced by digital cameras and saved as a digital file without any compression or post-processing. It allows the photographer to extract maximum quality and information.

Resolution
The amount of detail that can be resolved in an image. It is determined by the resolving power of the lens (i.e. lens sharpness), the grain structure of film, or the number of pixels that comprise the image. High-resolution images contain more detail and can be enlarged further when printing without the grain or pixel nature becoming visible.

Rubber Stamp
See Cloning.

Scanner
A computer input device used to input photographs and other artwork into a computer. Special backlit scanners can also input negatives and slides into a computer. Slide scanners are designed to scan slides and negatives, usually at a higher resolution.

Shadow
The darkest part of an image and the opposite of highlight. In a digital image the shadow is represented by tone 0.

Shutter
The mechanical device in the camera that opens to allow light from the scene through to the imaging sensor, which then affects the exposure.

Shutter priority mode
An exposure mode found in both digital and film cameras where the photographer selects the shutter speed and the camera automatically sets the aperture. This mode tends to be used for action photography and fast moving subjects.

Shutter speed
A measure of the length of time the shutter is kept open to allow an image to be formed.

SLR (Single lens reflex)
A camera in which the same prime lens is used for producing images, and feeds the viewfinder. Most – but not all – SLR cameras also feature interchangeable lenses. They are available in film and digital versions.

Spot metering
A metering mode where an exposure reading is made from a small discrete area of the scene (normally indicated by a circle at the centre of the viewfinder).

Stop
An alternate name for f stop. See f-stop.

Stop bath
A chemical used in film or paper processing, which comprises dilute acetic acid. It is designed to neutralise the alkali of the developer prior to immersing the film or paper in fixer bath.

Stop down
Decreasing the lens aperture (numerically increase the f-stop).

Tagged Image File Format (TIFF)
An image file format popular in digital cameras. Unlike JPEG, TIFF is lossless, which means it requires more storage space.

Telephoto lens
A lens with a long focal length and a narrower angle of view than a standard lens or the human eye.

Through-the-lens
A metering system that measures exposure through the lens used to take photographs (i.e. instead of using an external sensor that measures ambient lighting conditions).

TIFF
See Tagged Image File Format.

Tritone
An image produced by combining three colour channels in an image; often used to produce digitally toned black-and-white images.

TTL
See Through-the-lens.

Underexposure
A decrease in exposure resulting in less light reaching the film, sensor or the photographic paper (in the darkroom) than an accurate exposure would suggest.

Unsharp mask
A digital technique used to improve the sharpness of an image. It is the most effective (and controllable) of the sharpening filters.

USB
A communications system between a computer and peripherals (including cameras) for the transfer of data.

White balance
A camera control that can be set to automatic or manual to ensure that the colours in a scene are accurately reproduced, no matter what the lighting conditions. It can be disabled if a photographer wants to introduce deliberate colour casts.

Wide angle lens
A lens with an angle of view wider than a standard lens. Those with a wider angle of view are also called super wide, and those wider still are referred to as ultra wide.

Zoom lens
A camera or enlarger lens with variable focal length.

Acknowledgements

I could not have done this without the generous support of everybody who has contributed to this book – so a big fat huge thank you to everyone involved.

Brian Morris, you convinced me again. Leafy Robinson, Renée Last, Caroline Walmsley and Peter Cope – thank you for not giving up and for having acres of patience. Gavin Ambrose, thank your for the fantastic layout and design.

I would also like to thank all of the photographers who have kindly let me use their images in the production of this book, in particular, Gary Knight for always driving me forward and believing in making a difference.

I would like to dedicate this book to my little Milli moo min, your silly grumpy dad can now play Sylvanian families all weekend!